IMAGES
of America

MASSACHUSETTS
COVERED BRIDGES

IMAGES
of America

MASSACHUSETTS
COVERED BRIDGES

John S. Burk

ARCADIA
PUBLISHING

Published by Arcadia Publishing
Charleston SC, Chicago IL, Portsmouth NH, San Francisco CA

Printed in the United States of America

Library of Congress Control Number: 2009943922

For all general information contact Arcadia Publishing at:
Telephone 843-853-2070
Fax 843-853-0044
E-mail sales@arcadiapublishing.com
For customer service and orders:
Toll-Free 1-888-313-2665

Visit us on the Internet at www.arcadiapublishing.com

CONTENTS

ACKNOWLEDGMENTS

A project of this magnitude would not have been possible without the generosity and assistance of many individuals and institutions. For access to the handful of large collections that formed the heart of this project, thanks to Alexander Bardow of the Massachusetts Department of Transportation Bridge Section; Dick Chaisson from Athol; Peter Miller of Greenfield; Jim Miller, Betty Chapin, and David Prouty of the Sheffield Historical Society's Mark Dewey Research Center; and to Judy Warner and the Harvard Historical Society. Special thanks also to Bill Caswell, founder of the Covered Spans of Yesteryear project, for sharing a very useful database and passing along scans from several towns.

Equally important were contributors of images, sources, and information from individual towns and organizations, including Jayne Arata, Mary Bell, Jim Boone, Sylvia Buck, Julie Bullock, Dick Chaisson, Robert Cox and the University of Massachusetts Special Collections archives, the Chicopee Public Library, Nancy Dole, the Erving Public Library, Ed Finch, Jeanne Forand, the Harvard Forest, Tom Kelleher, Georgia Massucco and the Lee Library Association, Cliff McCarty, John McClure, Kathy Morris, David Norton, Pat Odinorne, Stan Olszewski, Jeanne Palmer, Gladys Pluta and the Williston Memorial Library in Easthampton, Stephen Roper, Jeanette Roubichaud and the Old Sturbridge Village Archives, M. E. Russell, Barbara Shiffer, Judy Schmitz, Bertyme Smith and the Barre Historical Society, Robb Strycharz, Judy Sullivan, Mary Thayer, the Ware Public Library, Katherine Westwood and the North Adams Public Library, Nancy Weyer, the Williamstown House of Local History, and Stephanie Young.

Many thanks to Erin Rocha, Ashley Boquist, and Jim Kempert, my editors at Arcadia Publishing, for encouragement and speedy assistance throughout all phases of this project and, as always, to my parents, John and Lale Burk, and brother, Nicholas, for their encouragement and support over the years.

This project is supported in part by a grant from the Petersham Cultural Council, a local agency that is supported by the Massachusetts Cultural Council, a state agency.

INTRODUCTION

While gathering images for this project during the summer of 2009, I took a brief detour off the Mohawk Trail Highway in Charlemont and followed Route 8A north through the recently renovated Bissell Bridge, a 60-foot-long covered bridge that spans a tributary of the nearby Deerfield River. A century ago, it was commonplace for travelers throughout Massachusetts to cross a covered bridge, but on this particular day, there was no other place in the state where one could drive along a public highway through one of these unique historic structures.

Indeed, the Bay State's handful of remaining historic covered bridges, a small fraction of the number found to the north in neighboring Vermont and New Hampshire, belies the fact that more than 270 such structures have been built across the state's numerous rivers, streams, and railroad crossings. This total includes multiple bridges built at the same location over time, but does not include those that are presently classified as private modern shelters.

The Massachusetts bridges existed in all shapes and sizes, from massive structures in the Connecticut and Merrimack Valleys that ranged from 800 to 1,300 feet in length to the diminutive 50-foot Adamsville Bridge in Colrain. The largest bridges featured multiple spans that were supported by broad stone piers in the riverbed. A few sturdy structures at Montague City, Northfield, and Newburyport were even used as combination bridges in which a railroad passed across the top.

Though information on covered railroad bridges is often scarce, sources indicate that roughly 100, or more than one-third of the state's overall total covered bridges, were built across the state during the 19th and early 20th centuries, including clusters near manufacturing centers such as Worcester, Athol, Holyoke, and Pittsfield. Many of these distinctive structures, which were built and maintained by private companies and faced the ever-present dangers of fire and heavy loads, had relatively short life spans and were lost during the 19th century. There are no surviving examples of covered railroad bridges in Massachusetts, and only a small handful remains in New England—in New Hampshire and Vermont.

The only documentation for some of the early town and railroad bridges are solitary appearances in drawings on old maps, vague citations in local histories and town records, and old photographs. In some instances, the year the bridge was built and/or lost and even its exact location are unknown. In towns where multiple covered bridges were built, it can be difficult to distinguish general references to "bridges" or "covered bridges." Further complicating research are instances such as the handful of postcards where towns are mislabeled or where single or generic images were used for multiple states (images labeled "Massachusetts" have in fact depicted covered bridges in the Midwest).

While covered bridges were built in all regions of Massachusetts, they were most common in the western and central hills. With 69 structures on record, Franklin County, which is bisected by the Connecticut River and is home to some of its largest tributaries including the Deerfield, North, and Millers Rivers, was the state's covered bridge center. Roughly 30 roofed spans were

situated in the neighboring towns of Colrain and Greenfield alone, and today the county hosts four of the state's remaining historic bridges. Thanks largely to its geographic size (an area roughly as large as Franklin, Hampshire, and Hampden Counties combined), Worcester County was a close runner-up, with 62 bridges. There were 46 covered bridges in Berkshire County, 43 in Hampden County, and 18 in Hampshire County.

Comparatively few covered bridges were located in the eastern region, where the climate is milder, the topography leveler, and the tidal rivers slower and gentler. The 13 roofed structures once found in Essex County along the Merrimack River Valley included several of the state's oldest and largest covered bridges, including the 800-foot-long Palmer and Rocks Bridges in Haverhill. There were roughly 20 more in Middlesex, Suffolk, Plymouth, Bristol, and Norfolk Counties combined.

From their heyday in the mid-to-late 19th century, covered bridges rapidly declined throughout Massachusetts and the rest of North America. Many structures, including well-known landmarks such as Springfield's famous Old Toll Bridge, the Long Bridge in Charlemont, and the Cheapside Bridge in Greenfield, were simply deemed obsolete and replaced by open iron, steel, and concrete structures built to accommodate increasingly-heavy automotive traffic. As the volume of motor vehicles increased, so did the chances of damage caused by accidents or oversized and overloaded vehicles, such as the truck that caused Greenfield's Smead Bridge to collapse into a pile of timbers in the Green River in 1932.

Fire was also an ever-present danger. Accidental blazes destroyed several structures, including those at South Royalston, Chicopee, and Mill Street in Greenfield during the early 1900s, and Northampton's South Street Bridge burned during the town's Forth of July celebration in 1893. The Upper Bridge in Sheffield, the Pumping Station Bridge in Greenfield, and Hadley's Hockanum Bridge all survived the various storms, winters, and years of vehicle use, only to sadly be done in by late–20th century arsonists.

The bridges were constantly stressed, of course, by New England's ever-notorious weather. In addition to the high waters that passed closely beneath—and often inundated—the fragile, exposed wooden floors each spring, the region endured several significant floods over the course of the 20th century. Chief among these were two especially devastating storms during the late 1930s that destroyed 20 of Massachusetts's remaining covered bridges, many of which were in marginal condition to begin with.

The great floods of March 1936 were the result of an unusual series of late-winter rainstorms that slowly passed over the northeastern United States while there was still a considerable snowpack across most of the region. The heaviest precipitation fell across the mountains of northern New England, rapidly thawing a season's worth of snowfall and unleashing extraordinary volumes of water that were abruptly released into hundreds of rivers and their tributaries. Roads, mills, dams, and bridges were swept away throughout all six states of the region, and there were even fears that the Connecticut River dam at Vernon on the Vermont-Massachusetts line would fail, which would have caused a catastrophic flood. Many covered bridges in the North, Green, and Deerfield River Valleys of Franklin County were washed out by the storm, including the 860-foot-long Montague City–Greenfield combination bridge.

The bridges hardy and/or fortunate enough to survive the 1936 floods faced an equally potent threat just two and a half years later, when the great hurricane of September 21, 1938, devastated much of Massachusetts and central New England. Forecasters initially assumed that this storm would follow the normal track of hurricanes along the coast, but instead it took an unusual turn inland and caused great damage and another round of substantial flooding throughout the region.

As the 20th century progressed, a shift in the perception of covered bridges became evident throughout Massachusetts and the rest of the country. There was initially little historical or romantic appreciation for the aging wooden spans, and towns and residents eagerly anticipated the construction of modern replacements. A newspaper account of the large fire that destroyed many buildings in South Royalston in 1904 declared that "no one would be sorry" about the loss of the village's covered bridge.

However, as the years progressed and covered bridges became increasingly rare, they became highly valued for their historic significance and as tourist attractions. Another newspaper article in the late 1930s mentioned "agitation to preserve the old [Partridgeville Bridge in Athol] as the last outpost of a fading past." During this time, the town of Charlemont petitioned the state for funds to rehabilitate the covered Long and Bissell Bridges, and though the former was rejected due to wartime restrictions, a new Bissell Bridge was completed in 1951, followed shortly thereafter by similar covered replacements in Sheffield and Pepperell. Though these structures differed in their predecessors in both interior and exterior design, they indicated a newfound desire by town residents to have covered bridges in their communities.

After the destruction of the Sheffield Upper and Greenfield Pumping Station Bridges by arson in the late 20th century, angered residents in both towns also rapidly commissioned replacement covered bridges. Ironically, the modern bridges had much shorter active lives than the originals, as the new Sheffield Lower Bridge was constantly plagued by problems and replaced by an open bridge in 1988, the Waterous Bridge in Pepperell was dismantled for repairs in 2008, and the aforementioned Bissell Bridge was closed to traffic from 1995 until renovations were completed in 2009.

In addition to its many historic bridges, Massachusetts was also home to several of the nation's pioneers of covered bridge design and engineering. The first of these was Timothy Palmer, who hailed from the North Shore town of Rowely. During the early 1790s, Palmer designed several large wooden arch bridges that were built in the Merrimack River Valley communities of Haverhill, Newburyport, and Lawrence and later expanded his efforts into the Mid-Atlantic states. After a Pennsylvania judge convinced him of the benefits of covered bridges, his "Permanent Bridge" over the Schuylkill River in Philadelphia subsequently became the nation's first such structure in 1805. In 1810, a roof was added to his existing bridge that connected Newburyport to Deer Island (one could thus anoint it as the country's first true "bridge that was covered," albeit retroactively), and in 1825, the massive Palmer-Haverhill Bridge, which was originally built in 1794, was also renovated and covered.

As the century progressed and covered bridges became commonplace, one of the most active builders was Issac Damon of Northampton, who oversaw the construction of a number of roofed structures throughout the Northeast from 1823 to 1850, including the 975-foot-long toll bridge that crossed the Connecticut River at Hartford, Connecticut. Damon was the earliest advocate of the distinctive architectural style known as the Town truss, which is easily distinguished from other designs by its checkerboard of diagonal timbers. Named for Ithiel Town from Connecticut, who pioneered the design during the 1820s, it became a popular choice for other New England bridge builders, as at least 76 structures featured this design.

Another widespread design, the Howe truss, was conceived by and named for Nicholas Howe, who was born in Spencer and moved to Warren during the 1830s. While working as a millwright, he observed some of the bridges that were built by the Western Railroad Company and conceived a stronger design that pioneered the use of iron rods to supplement the wooden timbers. The Howe truss was patented in 1840—two years after Howe completed a railroad bridge over the Quaboag River near his home—and was subsequently used in railroad and highway bridges throughout North America, Europe, and Russia through the late 19th century. Today approximately 125 covered bridges with this design remain standing throughout the United States.

All told, covered bridges have been documented in Europe and the Far East as far back as the Middle Ages. Since the opening of Palmer's Permanent Bridge in 1804, more than 13,000 known roofed spans have been built throughout North America, with the height of popularity in the mid-to-late 19th century. While numerous theories have been offered over the years as to why bridges were covered, the simple answer is the roof and sides protected the wooden frame and floorboards and allowed them to last much longer than if continuously exposed to the elements. In winter, a light coating of snow was actually spread across the floors of some bridges, allowing for an easy passage of sleighs. The bridges were integral parts of the communities they served, as before the onset of modern roads, automobiles, and trucks, the loss of a river crossing had serious implications for remote rural towns and villages.

The Massachusetts covered bridges were joined by nearly 1,100 similar structures in the neighboring New England states. More than 500 of these were located in Vermont alone, and though more than 80 percent of these have been lost to events such as the great flood of 1927, the state retains the region's largest concentration of surviving historic covered bridges. Neighboring New Hampshire has 53 remaining out of nearly 400, and a mere half-dozen are left from the 120 that once spanned Maine's numerous waterways. In southern New England, Connecticut has just three left out of 60, though two of these continue to serve public roads in the northwest hills. Rhode Island was home to two highway and three railroad covered bridges, the last of which was lost in 1955 (a road bridge was built in the town of Foster in 1993).

The handful of remaining historic covered bridges in Massachusetts are well dispersed across the state in the southern Berkshires town of Sheffield; Conway and Charlemont in the western foothills; Colrain and Greenfield in the upper Connecticut Valley; Hardwick in central Worcester County; and Pepperell in the northeast region. A unique circumstance occurs at Old Sturbridge Village where a bridge that once was located along a tributary of the West River in the southern Green Mountains of Vermont was dismantled, moved, and rebuilt as an exhibit in the historic village in the early 1950s. Directions to these structures are as follows:

Sheffield/Upper: This bridge is located on the east side of Route 7, just north of the center of Sheffield and south of the Great Barrington town line.

Conway/Burkeville: From Route 116 in the center of Conway (accessible via Exits 24 or 25 on Interstate 91), continue west to the village of Burkeville. The bridge is on the south side of the highway, opposite a historic church.

Charlemont/Bissell: From the junction of Routes 8A and 2 (the Mohawk Trail Highway) in Charlemont, turn north on Route 8A and continue for 0.2 miles to the bridge.

Colrain/Arthur Smith: From the junction of Route 2 and Route 112 north near Shelburne Falls, follow Route 112 north for 4.8 miles, then turn west on Lyonsville Road, and continue to the bridge entrance.

Greenfield/Pumping Station: This bridge is somewhat off the beaten path; to reach it take Interstate 91 to exit 26, then travel east on Route 2A to a left on Conway Street, then left on Nash's Mill Road, then right on Colrain Road, then quickly bear right on Plain Road, then continue 3 miles to another right on a side road that leads 0.2 miles to the bridge.

Ware-Gilbertville: From the junction of Routes 9 and 32 in Ware, follow Route 32 north for 3 miles to Gilbertville, a village of Hardwick. Look for Bridge Street on the west side of the highway, just south of the junction with Route 32A. Renovations to this structure began in 2010.

Dummerston–Old Sturbridge Village: This bridge, which originally was located in southern Vermont, is now part of the exhibits at Old Sturbridge Village, which is on Route 20 in Sturbridge.

Pepperell: From the junction of Routes 111 and 113 in Pepperell, follow the latter north for 0.8 miles, then bear left at an intersection and continue for another 0.2 miles. The bridge was dismantled in 2008 for renovations but is scheduled to reopen in 2010.

One

SHEFFIELD AND THE BERKSHIRES

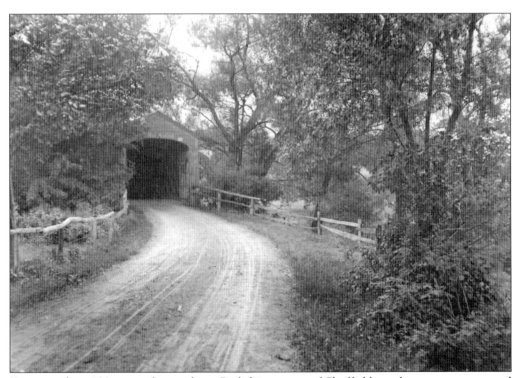

For more than 130 years, the southern Berkshires town of Sheffield was home to two covered bridges that crossed the Housatonic River near the village center. The northernmost of these was the Upper Bridge, which crossed the river at Sheffield Plain slightly less than a mile from the town's main intersection. (Courtesy Sheffield Historical Society Mark Dewey Research Center.)

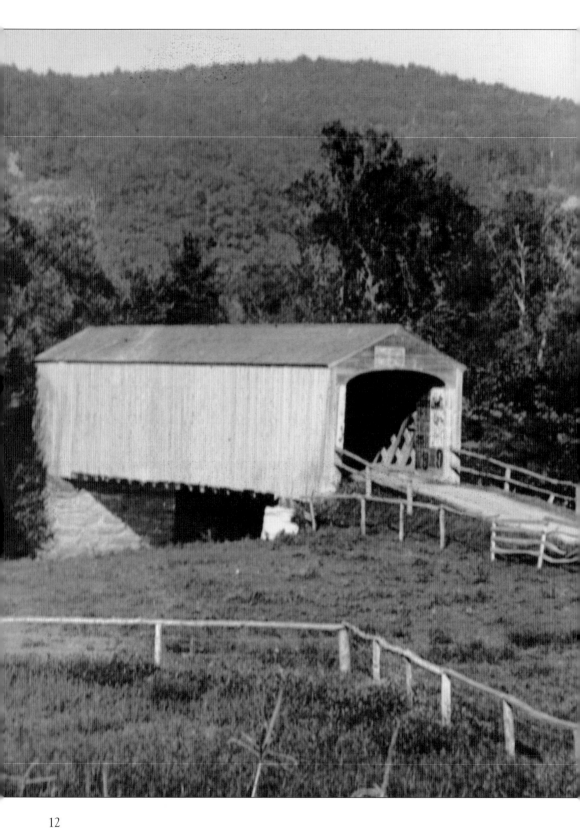

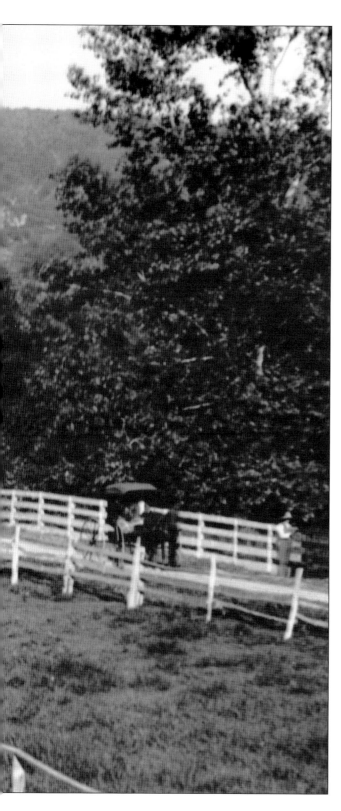

The Sheffield Upper Bridge, which replaced a previous structure that was known as the Hubbard Bridge, was located in a scenic setting below the rolling hills of the Housatonic Valley. The exact year of its construction has been an issue of debate, with estimates ranging from the early 1830s (likely as a result of confusion with town records referencing the Lower Bridge, which was built during that time) to as late as 1855; however, a recent inventory of the town records has fixed 1854 as the most likely date. (Courtesy Sheffield Historical Society Mark Dewey Research Center.)

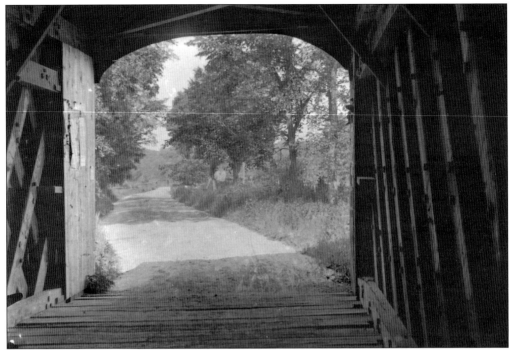

The Upper Bridge was an important link in the old post road that connected Boardman Street on the east side of the river to the village center. Mail was delivered to the town via the old Hartford Trail (the current Route 44). Visible on both sides of the image is the bridge's Town truss frame, easily distinguished by its diagonal checkerboard timbers. (Courtesy Sheffield Historical Society Mark Dewey Research Center.)

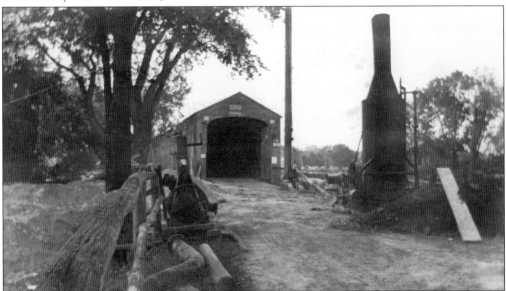

Early–20th century repair efforts are seen here on the Upper Bridge. The pine timbers used in the construction of the original 93-foot-long span proved up to the task of withstanding many long winters in the Housatonic Valley, and the bridge served traffic on an active town road off of Route 7 for more than 120 years. (Courtesy Sheffield Historical Society Mark Dewey Research Center.)

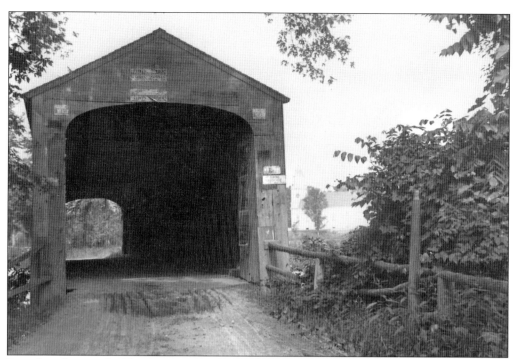

Posted on the portal of the Upper Bridge were signs for Flint's Powders, Kendall's Spavin Cure, and Magic Yeast, all of which were familiar advertisers on covered bridges throughout the Northeast. A notice posted by the town selectmen prohibited trash dumping at the site. An 1864 town bylaw prohibited "firing of powder and shot through the roof." (Courtesy Sheffield Historical Society Mark Dewey Research Center.)

This well-framed, mid-20th century view of the Upper Bridge was taken by William Maxant during a Berkshires trip in the summer of 1949. In 1967, the bridge's load capacity was reduced to 3 tons, and it was finally closed to traffic altogether in 1974. (Courtesy Harvard Historical Society.)

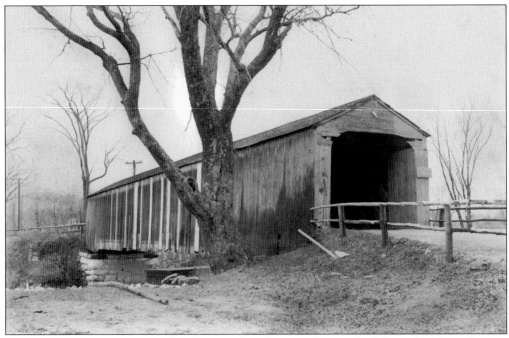

As the 20th century progressed and covered bridges rapidly vanished from the Massachusetts landscape, the Sheffield Upper Bridge became the state's oldest surviving covered span. While it was spared the brunt of the storms of the 1930s that destroyed many bridges in the Connecticut Valley and western hills, it was still subject to vehicle traffic, long winters, annual spring freshets, and storms. Many replacement boards are visible in the above image, while two birds below enjoy an elevated view as the floodwaters of 1949 rise precariously close to the bridge's floor. (Above, courtesy MassHighway Bridge Section Archives; below, courtesy Sheffield Historical Society Mark Dewey Research Center.)

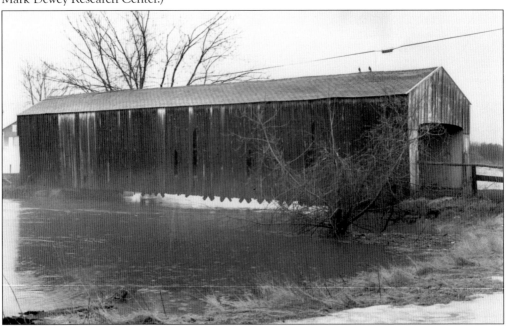

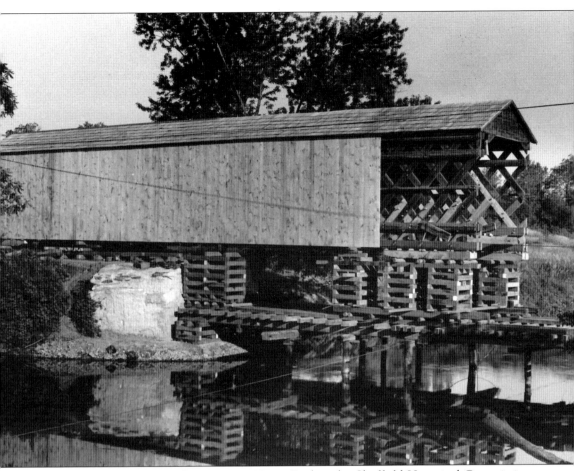

In order to rehabilitate the deteriorating Upper Bridge, the Sheffield Historical Commission undertook an active fund-raising campaign. The town residents and area businesses contributed $25,000, which was matched by a grant from the Massachusetts Historical Commission. The project was awarded to Milton S. Graton and his son, Arnold, from Ashland, New Hampshire. Milton Graton began working on covered bridges during the mid-1950s and oversaw the construction or restoration of more than 30 structures until his death in 1994. One of his bridges across the Connecticut River in New Hampshire was featured in *On the Road with Charles Kuralt*, and he was the subject of a biography titled *The Last of the Covered Bridge Builders*. His family continues to operate a business that has restored structures across the country for more than 50 years. The rebuilt Upper Bridge was dedicated on October 4, 1981. Unfortunately, it was destroyed by arsonists on August 13, 1994. (Courtesy Sheffield Historical Society Mark Dewey Research Center.)

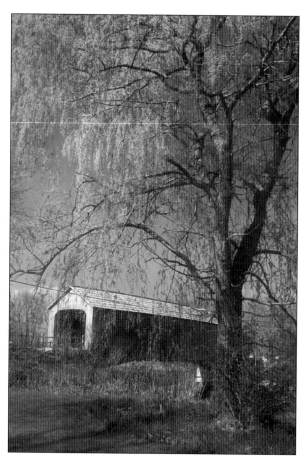

In the aftermath of the fire, the residents again demonstrated their affinity for the Upper Bridge by commissioning an identical replacement, which was completed in 1998. Some timbers salvaged from the remains of the original were used in the construction. Though closed to vehicles, it remains a popular attraction along historic Route 7. (Photograph by author.)

For more than 130 years, the Upper Bridge had a companion covered bridge a short distance downstream. Shown here is the first of two structures that were known as the Lower Bridge. This bridge, which spanned an oxbow bend in the Housatonic River, was built in 1835 and was one of the state's oldest covered bridges. (Courtesy Sheffield Historical Society Dewey Research Center.)

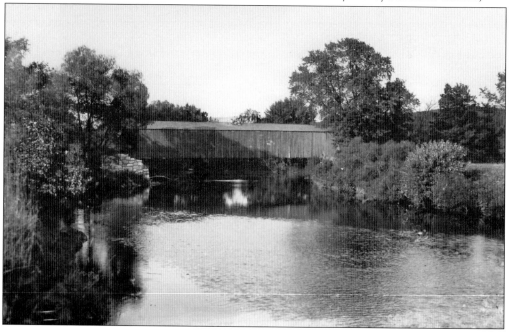

Pictured here is the portal of the first Lower Bridge, which served a heavily used crossing along Maple Avenue, half a mile from the town center. Town records indicate that the original roof of the bridge was replaced in 1864, after lasting 27 years. Shortly after its construction, the town passed an act penalizing anyone who drove horses over it at a faster pace than a walk. (Courtesy Sheffield Historical Society Mark Dewey Research Center.)

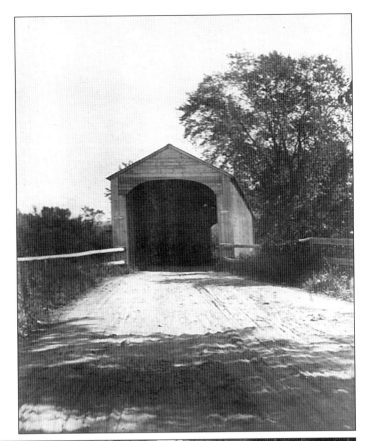

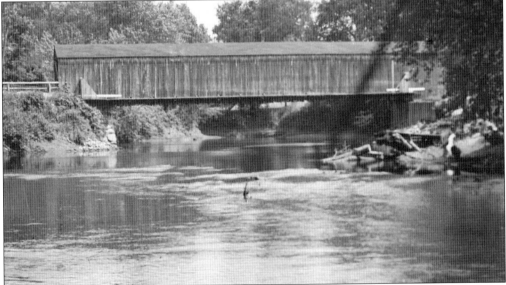

At 126 feet, the first Lower Bridge was roughly 30 feet longer than the Upper. The frame and sideboards of both of these hardy structures were constructed with pine timbers. The Lower Bridge survived the floods of 1927, 1932, 1938, and 1949 in good order, before being replaced by the second Lower Bridge. (Courtesy Sheffield Historical Society Mark Dewey Research Center.)

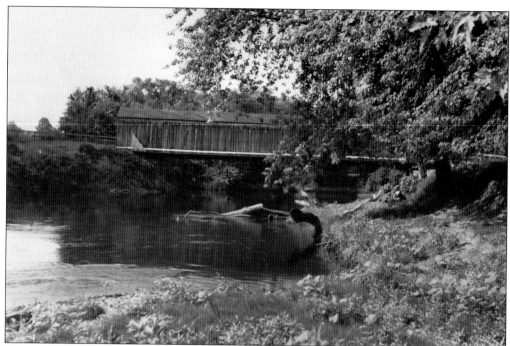

The original Lower Bridge is pictured here in 1949, shortly before it was dismantled in 1952 after nearly 120 years of service. The bridge and its timber were offered for sale for $1 to anyone who wished to move it elsewhere. Though most of its boards and frame were moved to a nearby field and burned, a few pieces were kept by local residents as souvenirs. (Photographs by William Maxant; courtesy Harvard Historical Society.)

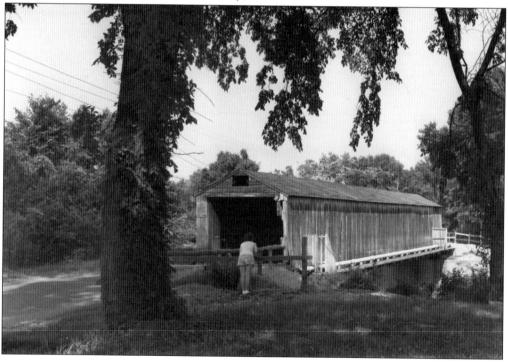

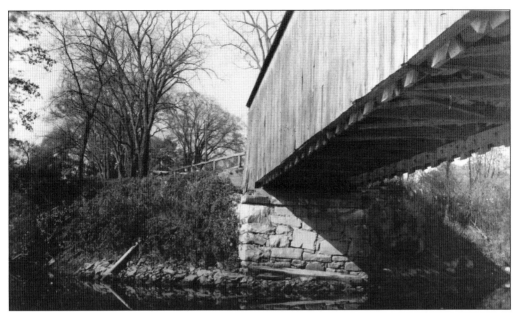

This close-up view of a stone abutment and floor of the first Lower Bridge was taken during a state bridge inspection during the 1920s. Though no fatalities were ever associated with accidents involving the bridge, in one particular early–20th century incident a rotting section of the floor collapsed, dropping a couple that was driving a cart loaded with shad into the river. (Courtesy MassHighway Bridge Section archives.)

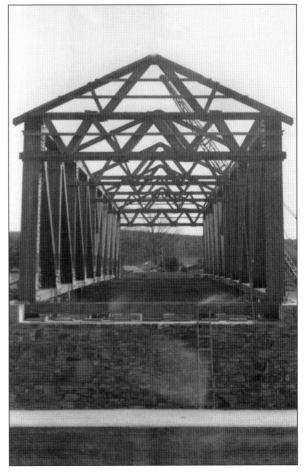

The second Lower Bridge was constructed in 1952 over a newly excavated channel of the Housatonic River a short distance from the site of the first bridge. The new bridge's frame featured a modern variation of the Pratt truss design, which is characterized by single diagonal support beams and has been used in the design of four other New England covered bridges. (Courtesy MassHighway Bridge Section archives.)

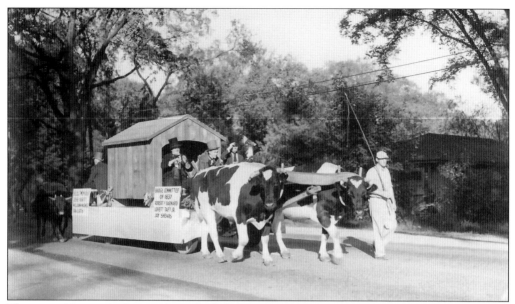

The second Lower Bridge was formally dedicated during an elaborate ceremony in October 1953. This float, which included a replica covered bridge, was part of the festivities. The signs list the members of the town bridge committee and selectmen who authorized the construction of the original Lower Bridge. The present whereabouts of the replica is unknown. (Courtesy Sheffield Historical Society Mark Dewey Research Center.)

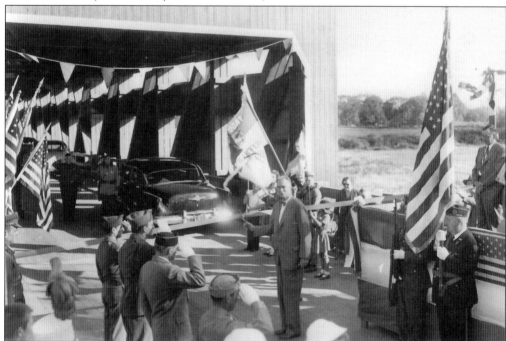

Massachusetts governor Christian Herter (center) was among the more than 200 people who were present at the dedication of the new Lower Bridge. The governor was joined by a school band, representatives from the county, and townspeople dressed in costumes from the 19th century. (Courtesy Sheffield Historical Society Mark Dewey Research Center.)

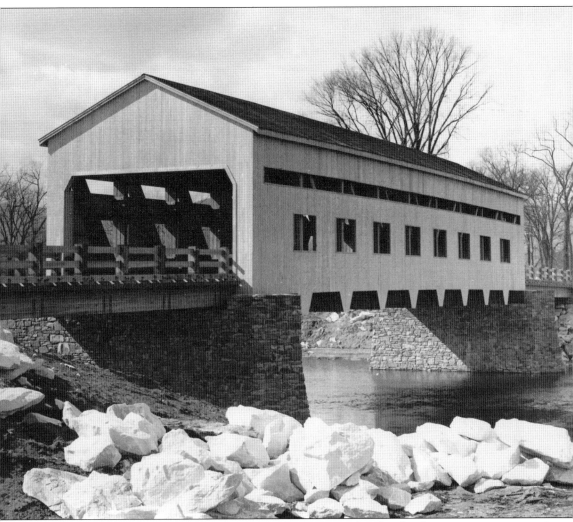

Ice blocks along the Housatonic River frame the new Lower Bridge shortly after its construction. The light tone of the boards suggests that this image was taken shortly after the work was completed, but before it received its distinctive coat of red paint. The replacement Lower Bridge was the second of the three "Massachusetts modern" covered bridges that were built to replace decaying, historic 19th-century structures; the others were Charlemont's Bissell Bridge and the Chester Waterous Bridge in Pepperell. Unlike restored bridges in recent years that have been designed to the specifications of the originals, all three featured entirely different exterior and interior designs than their predecessors. Though it was built to accommodate heavy automobile traffic, the new Lower Bridge remained in service for only 35 years, a much shorter life span than the original. (Courtesy MassHighway Bridge Section archives.)

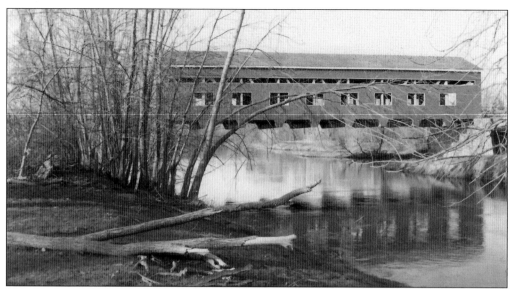

The residents of Sheffield petitioned for a new covered bridge to replace the original Lower Bridge, reflecting the increased sentiment for these structures as the 20th century progressed. The 135-foot-long new Lower Bridge was easily distinguished from its predecessor by its distinctive row of eight large windows, which were characteristic of the other covered bridges that were built in Charlemont and Pepperell during the mid-20th century. It was enlarged to a width of 24 feet, allowing for three vehicles to pass at a time. The design was created by the Timber Engineering Company (TECO) of Washington, D.C., and was built at a cost of $250,000. (Courtesy Sheffield Historical Society Mark Dewey Research Center.)

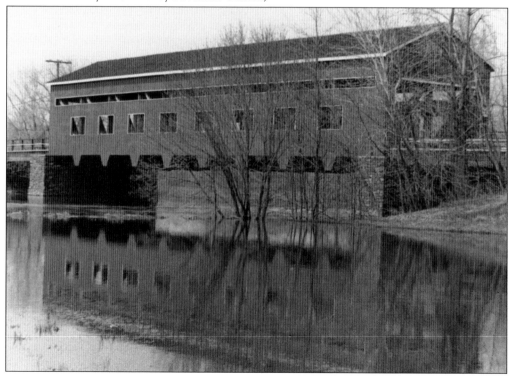

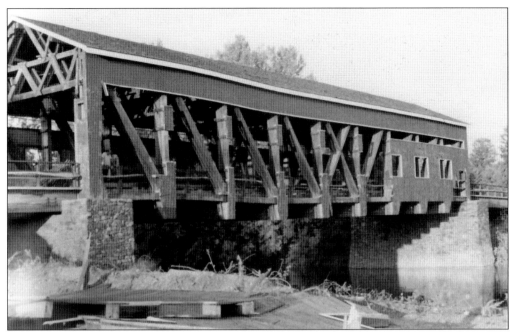

The second Lower Bridge was continually plagued by structural and maintenance problems from the time of its opening onward. Some of the structure's beams split within its first year, and the railings came apart shortly thereafter. In 1960, portions of the bridge were reinforced with steel. By 1986, the bridge had suffered considerably from regular crossings of overloaded trucks. (Courtesy Sheffield Historical Society Mark Dewey Research Center.)

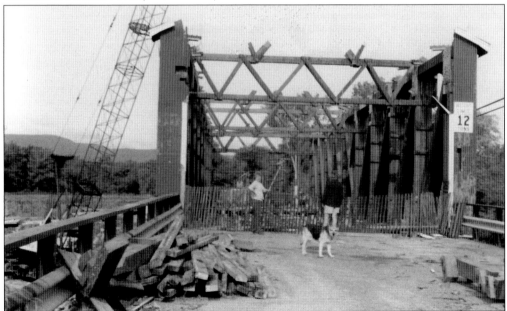

Though another petition signed by 200 requested that a covered bridge continue to be maintained on the site, town officials and most other residents favored an open steel bridge. The Lower Bridge was dismantled during the summer and fall of 1987, and for the first time in 150 years, there was no covered bridge at this crossing. (Courtesy Sheffield Historical Society Mark Dewey Research Center.)

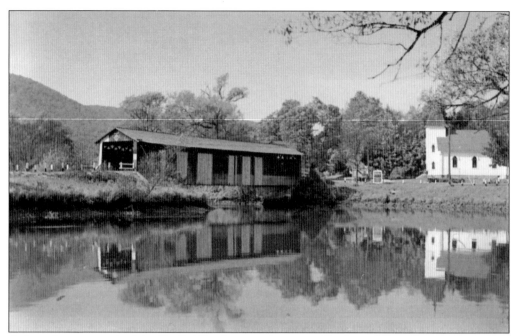

A short distance north of the Sheffield bridges was the covered bridge at South Lee, which spanned the Housatonic River in an especially picturesque location along the road to Great Barrington. This 128-foot-long span, which was also known as the Main Street or Long Street Bridge, was built during the Gold Rush year of 1847. The patchwork of boards is evidence of repairs to the sides over the years. (Courtesy Lee Library Association.)

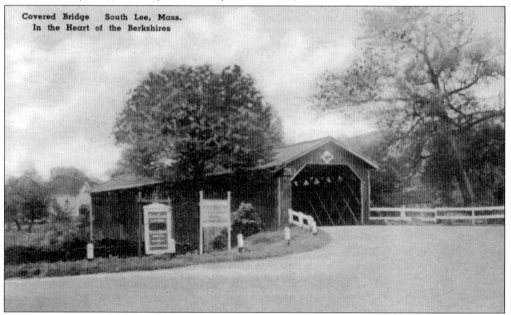

For many years, the structure of the South Lee covered bridge supported heavy loads of timber cut from the nearby forests at Beartown. In *The Story of Covered Bridges*, Adelbert Jakeman recounted how "Through its narrow tunnel rushed the excited populace when the local powder mill blew up some time ago." (Courtesy Lee Library Association.)

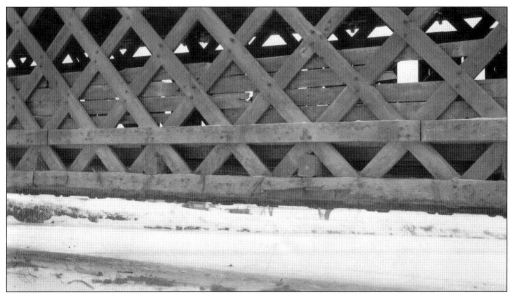

This image provides a close-up view of the Town truss frame and floor of the South Lee Bridge, taken during a 1930s inspection for ice damage. In its final years, the bridge was open only for pedestrians, as it was closed to vehicles after being damaged by an accident involving a tractor-trailer truck. (Courtesy MassHighway Bridge Section archives.)

Above is an artist's rendition of the South Lee Bridge from the archives of the Massachusetts Highway Department's Bridges Section. As happened with the Sheffield Lower Bridge, the bridge was offered for sale to the highest bidder prior to its teardown, and one local newspaper article expressed hope that it could be relocated to a nearby stream crossing. (Courtesy MassHighway Bridge Section archives.)

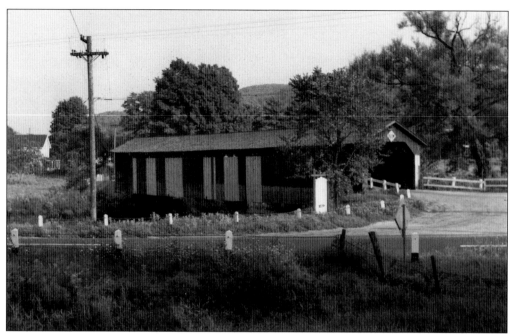

The South Lee covered bridge is shown in 1949, shortly before the popular landmark was dismantled in 1954 and replaced by an open bridge. Along with the nearby Upper and Lower Bridges in neighboring Sheffield, it was one of the last three covered bridges remaining in the Berkshires. (Photograph by William Maxant; courtesy Harvard Historical Society.)

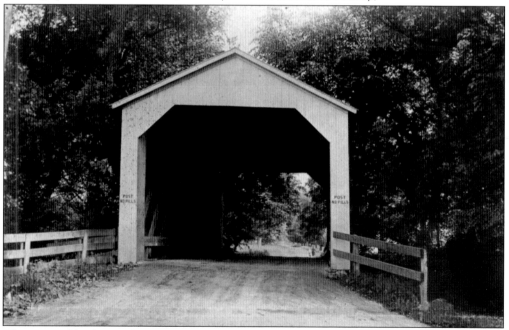

This covered bridge was located on Route 7 at Sand Springs in Williamstown. Here it spanned Broad Brook, which was described in a town history as "the most treacherous stream in the northern Berkshires." Indeed, it was the only bridge that survived an especially damaging flood along this waterway in 1891. (Courtesy Nancy Weyer.)

Five lines of tracks operated by the Fitchburg Railroad (originally the Troy and Boston and subsequently the Boston and Maine Railroad) crossed in front of the portal of Williamstown's Moody Bridge, which spanned the Hoosic River. This single-span structure, which was also known as the Cole's Crossing Bridge, had its roof blown off by a storm in 1862. It was replaced with an open bridge during the 1890s. With two major rivers and a dozen smaller streams and brooks, Williamstown has long been prone to flooding, and many of its bridges were damaged by another storm during August 1901. (Both courtesy Williamstown House of Local History.)

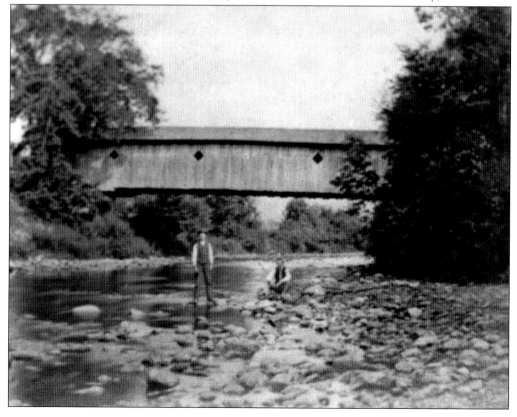

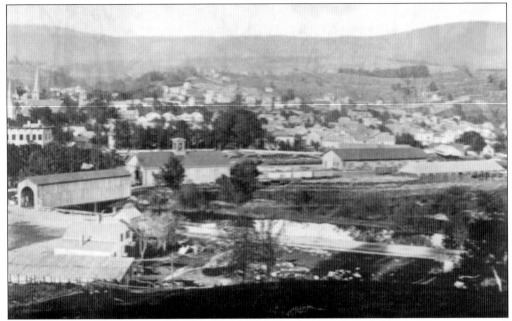

In the valley beneath Mount Greylock, the town of North Adams was home to 11 known covered bridges that spanned the Hoosic River and its tributaries, including three railroad bridges. In the town center, covered bridges were located at crossings on Main, Union, and Eagle Streets and adjacent the rail yards on State Street. (Courtesy North Adams Public Library.)

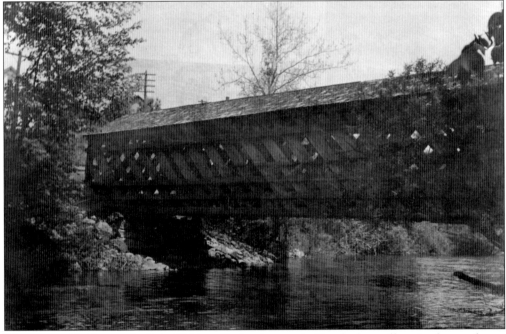

This covered bridge was built in 1847 on Phelps Avenue in Greylock, a village in the northwest corner of North Adams near the Williamstown town line. Its exposed Town truss frame is visible in this image. Most of the town's covered bridges were relatively short-lived and were gone by the late 19th century. (Courtesy North Adams Public Library.)

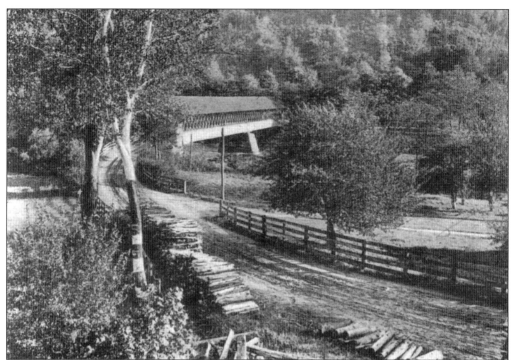

Located in an especially scenic setting in the town of Florida on the Berkshire-Franklin County line, the Hoosac Tunnel "Station Two" Bridge was built by the Boston and Maine Railroad in 1870 to provide a direct route across the Deerfield River from the village at Hoosac Tunnel to the nearby railway depot. It was maintained by the railroad company until its loss in 1915. A large stone abutment served as a central pier that supported the structure's twin spans. Water barrels were located at each end of the structure for use in putting out potential fires. (Above, author's collection; below, courtesy Peter Miller.)

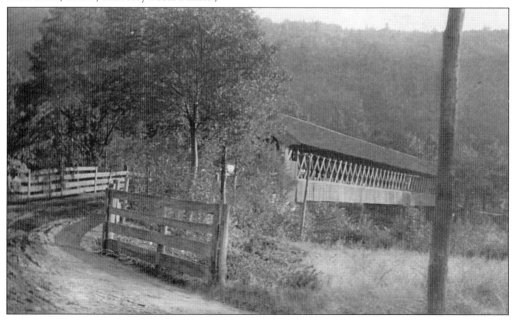

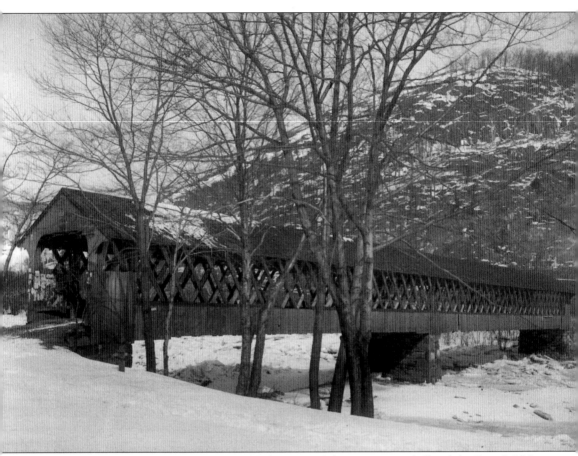

The Hoosac Tunnel Bridge is nestled below one of the many steep hills of the Deerfield River Valley in this winter view. The bridge's partially open sides offered a photogenic view of its Town truss frame, though it also subjected the exposed timbers to the harsh winters of the northern Berkshire region. The nearby Hoosac Tunnel is a significant landmark of American railroad history, as it provided a 4-mile route through the base of East Mountain, which allowed trains an easy passage through the northern Berkshire Hills as part of the crucial line to Albany and beyond, but at the cost of nearly 200 workers who died during its construction. Florida was also home to several other covered bridges, including a structure known as the "Little Bridge in the Hollow" that crossed the Cold River, and the Zoar Bridge, which provided a crossing of the Deerfield River to the town of Rowe in northwest Franklin County. (Courtesy North Adams Public Library.)

Two

THE WESTERN HILLS

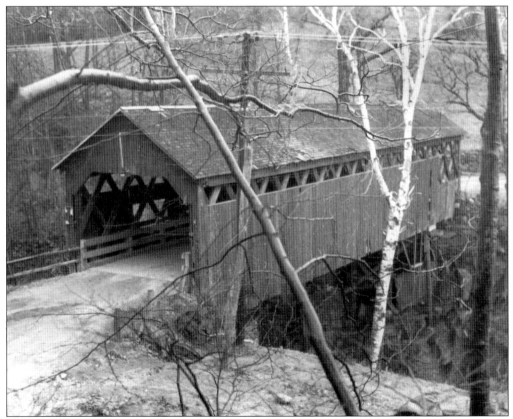

Since 1880, the narrow valley of Mill Brook in Charlemont has hosted a covered bridge. Shown here is the first of two structures that have been built on the site, both of which have been known as the Bissell Bridge after town resident Adam Bissell, whose home was adjacent to the crossing. The bridge site is half a mile north of Charlemont center and the Mohawk Trail Highway. (Photograph by William Maxant; courtesy Harvard Historical Society.)

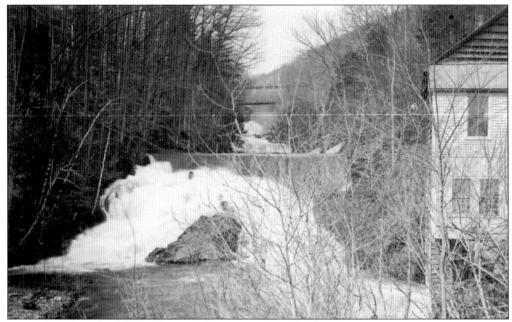

The active waters of Mill Brook cascade past an old mill in a small gorge a short distance downstream from the first Bissell Bridge, which is visible above the upper waterfall in this c. 1910 view. This picturesque, seasonal brook is a tributary of the nearby Deerfield River. (Courtesy Peter Miller.)

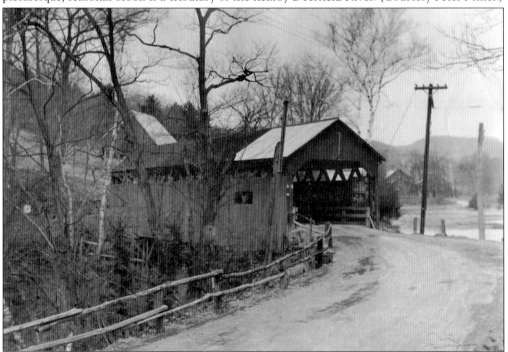

The southeast portal of the first Bissell Bridge is pictured here in April 1939. Heavily loaded trucks from nearby mines contributed significantly to the deterioration of the structure in the early to mid-20th century, and a 2-ton limit was posted per request of the town selectmen. (Photograph by William Maxant, courtesy Harvard Historical Society.)

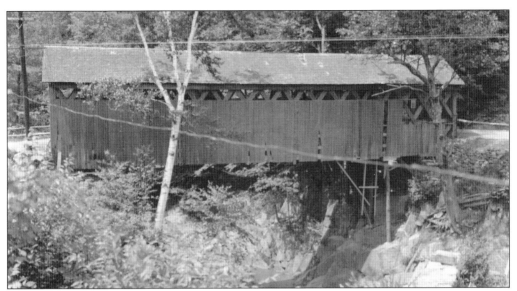

At a mere 60 feet in length, both Bissell Bridges are among the shortest covered bridges on record in Massachusetts. Because it was perched high above a narrow, seasonal brook, the original bridge, shown here in 1940, was able to survive the 1930s storms that destroyed most of the neighboring Franklin County covered bridges. (Courtesy MassHighway Bridge Section archives.)

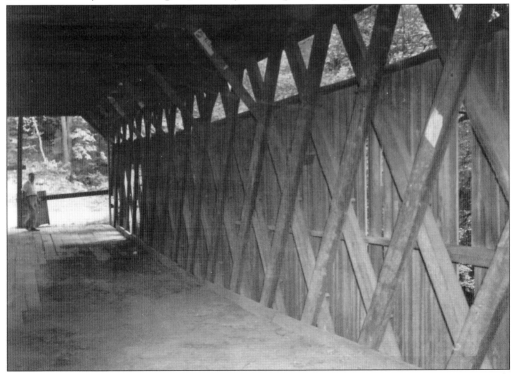

The interior of the first Bissell Bridge is seen here in August 1950, just before construction work began on the replacement. This iteration of the bridge featured a Town truss design, while the new structure used a variation of the Long truss design. Gates blocked the entrance after the structure was condemned. (Courtesy MassHighway Bridge Section archives.)

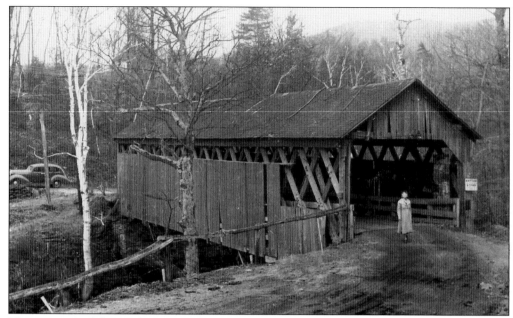

This is a view of the northwest portal of the first Bissell Bridge in April 1939, the year before the structure was condemned and closed to traffic. In the foreground is Helen Maxant, wife of photographer William Maxant. Note the exposed Town truss frame behind the missing boards. After 10 years of inactivity, the bridge was finally dismantled and replaced by an all-new structure. The work was done by contractor T. J. Harvey of North Adams. (Photograph by William Maxant; courtesy Harvard Historical Society.)

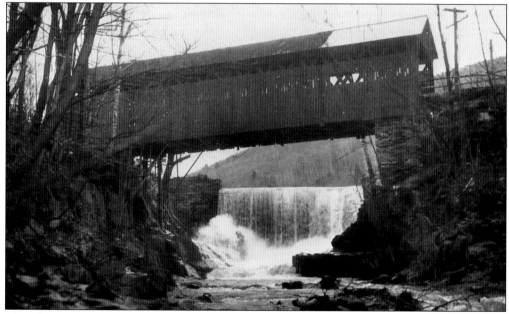

This photograph of the first Bissell Bridge, taken from the bed of Mill Brook just below the bridge and falls in 1939, makes for a good comparison with the image of the replacement structure and its entirely different design on the opposite page. (Photograph by William Maxant; courtesy Harvard Historical Society.)

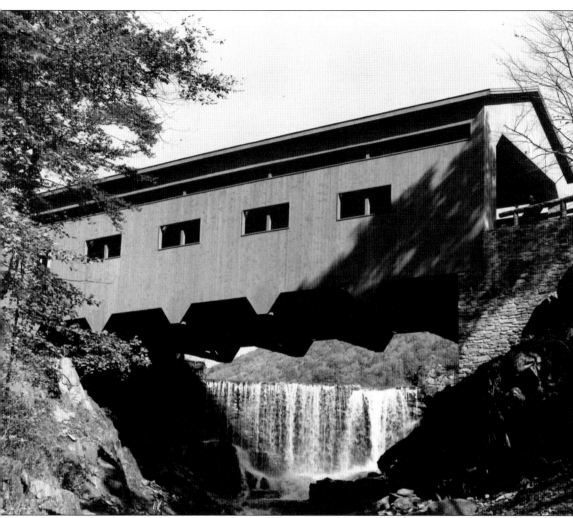

In contrast to renovations that have been done to New England's historic covered bridges in recent years, where maintaining the architecture of the original has been a priority, the second Bissell Bridge differed from its predecessor in both interior and exterior design. Like other modern covered bridges that were erected in Sheffield and Pepperell during the mid-20th century, this bridge featured a row of windows along both sides. The interior frame was a Long truss variant, as opposed to the Town truss of the first bridge. The town phrased their applications to the state for funding to rehabilitate the Long and Bissell Bridges as poems; the latter bid proved successful due to its falling outside of the timber restrictions of World War II: "The Bissell Bridge is falling down, / Right in the middle of our town. / Please view the matter with alarm, / And do vote Yes unto our plan." (Photograph by W. E. Robinson; courtesy MassHighway Bridge Section archives.)

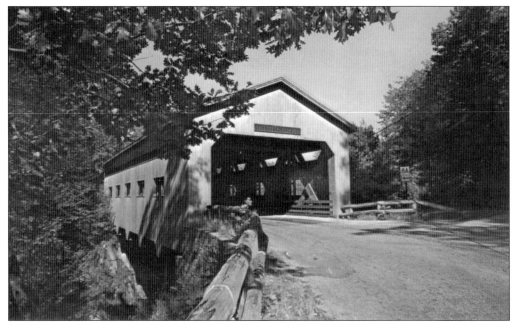

The second Bissell Bridge was used by vehicles from 1951 until wear and deterioration caused it to be closed to traffic in 1995. A bypass was built around the upstream side of the bridge after it was closed. It remained a popular stop for tourists, who enjoyed easy access to the structure via Route 8A and the Mohawk Trail Highway. (Courtesy Erving Public Library.)

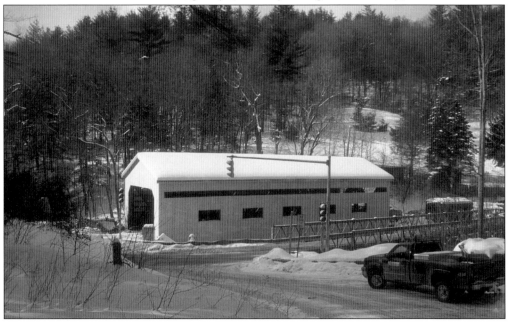

The Bissell Bridge is one of four historic covered bridges in Franklin County, all of which have been rebuilt or substantially renovated since 2005. Here work nears its completion in February 2009, shortly before it was reopened to vehicles. With repairs pending for the Ware-Gilbertville and Pepperell Bridges, the Bissell Bridge was the only covered bridge open to traffic in Massachusetts during this time. (Photograph by author.)

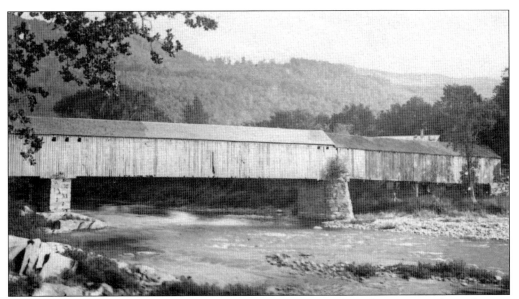

The aptly named Long Bridge was one of three covered bridges that remained standing in Charlemont through the mid-1930s and was the last that remained in service over the Deerfield River. Built in 1833, it was one of the state's oldest covered bridges. (Courtesy Peter Miller.)

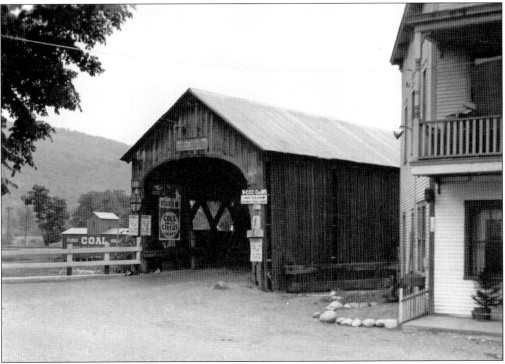

Above is a c. 1937 view of the north portal of the Long Bridge from the Route 2 entrance. This bridge was a popular attraction of the Mohawk Trail highway and was located in an especially scenic setting amidst the hills of the valley. Signs post an appearance of Cole's Circus, the nearby railroad crossing, and directions to a CCC camp 4 miles away. (Courtesy MassHighway Bridge Section archives.)

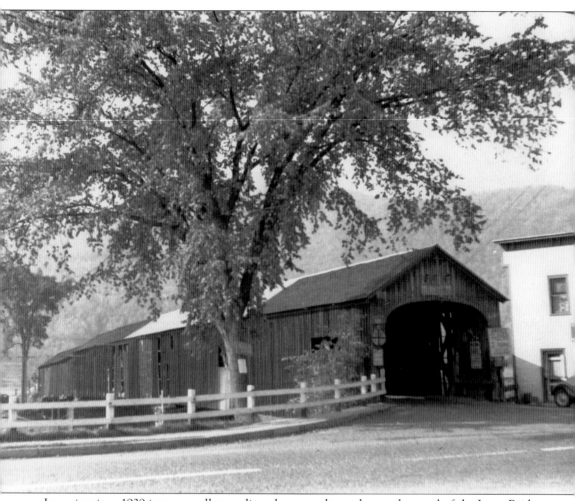

In an ironic *c.* 1939 image, a tall spreading elm tree adorns the north portal of the Long Bridge. Like most of the state's covered bridges, elms have also largely disappeared from the Massachusetts landscape. Though the Long Bridge survived the storms of the 1930s, it suffered considerable damage during this time and was closed to traffic the year that this photograph was taken. In an "Application for Old Bridge Assistance," the town selectmen presented the following poem to the state Department of Public Works: "For a hundred years this bridge has stood, / But for the past 15 has been no good. / And loving hands have patched its pants, / 'Til naught remains but food for ants. / By the Grace of God it stands today, / Exactly why no man can say. / But in the breeze its sways and jerks / Should give the chills to the Public Works." (Photograph by William Maxant; courtesy Harvard Historical Society.)

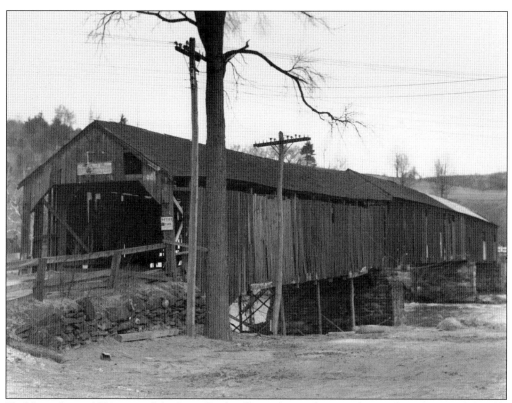

Visible in this c. 1939 view of the Long Bridge (from the road to Hawley on the river's south bank), beneath the first span, are wood beams that were erected in the riverbed to provide additional support to the aging structure. Note the slight difference in the south portal compared to the rounded north entrance in the previous images. (Photograph by William Maxant; courtesy Harvard Historical Society.)

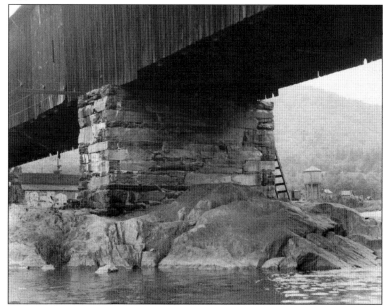

A close-up, river-level view shows one of the Long Bridge's two stone abutments. The bridge's three spans totaled 324 feet, which was more than five times the length of the nearby Bissell Bridge. This view was taken by the state bridge department in 1937, shortly before the bridge was closed. (Courtesy MassHighway Bridge Section archives.)

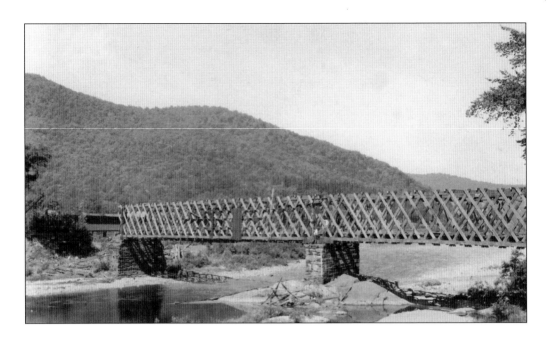

These photographs show the final days of a familiar landmark; the Town truss frame of the Long Bridge is exposed above the Deerfield River during the dismantling of the structure in 1944. At the time of its loss it was the oldest covered bridge in Massachusetts. Though there was support for rehabilitating the Long Bridge as a covered structure and notes in state records indicated a replacement covered bridge was planned, wartime shortages of timber prompted the construction of a steel and concrete crossing. Had the proposal been made just a few years later, as was the case with the nearby Bissell Bridge, there might be two remaining historic bridges in Charlemont. (Both courtesy MassHighway Bridge Section archives.)

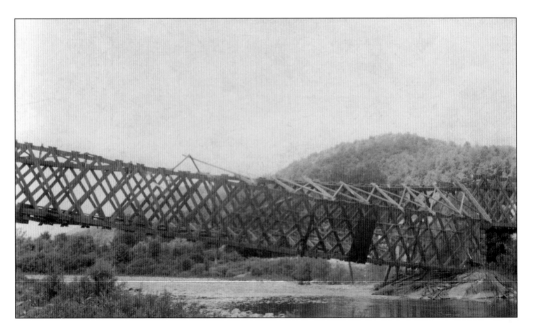

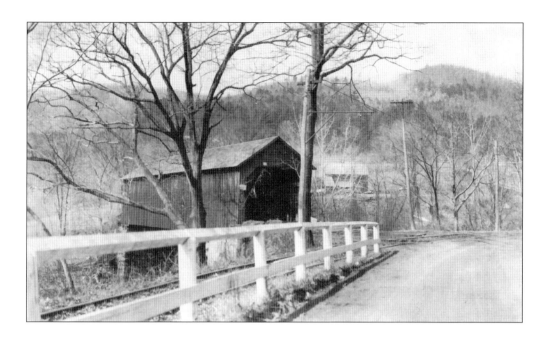

From high atop stone supports, the North River Bridge spanned the North River at its confluence with the Deerfield River at the Charlemont-Shelburne town line. In 1935, Adelbert Jakeman, noting the bridge's relatively good condition and location on a lightly traveled side road west of the Mohawk Trail Highway, wrote that it "should be preserved for many years to come for posterity to admire." Unfortunately, within a year of this assessment, it was one of the many covered bridges in Franklin County that were destroyed by the floods of March 1936. (Both courtesy MassHighway Bridge Section archives.)

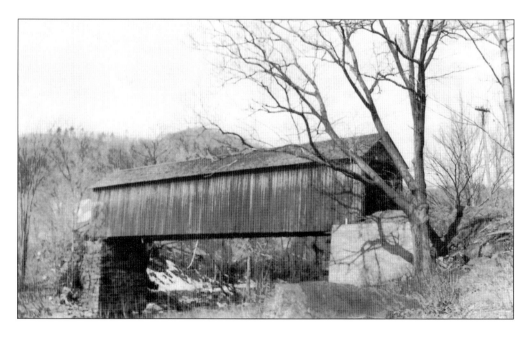

This view from the interior of the North River Bridge shows the country lane and the hills of the Deerfield River Valley. The walls of this and many other covered bridges were traditionally decorated with posted advertisements for shows, circuses, and various products and services, some of which were quite elaborate. (Courtesy Peter Miller.)

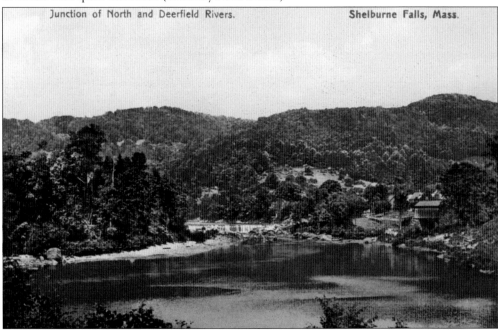

The North River Bridge, visible on the right-hand side of this postcard, was situated in a picturesque setting at the confluence of two scenic rivers. After it was washed off its supports in 1936, it was set on fire so that it would not be swept downstream into the nearby Bridge of Flowers at Shelburne Falls. (Author's collection.)

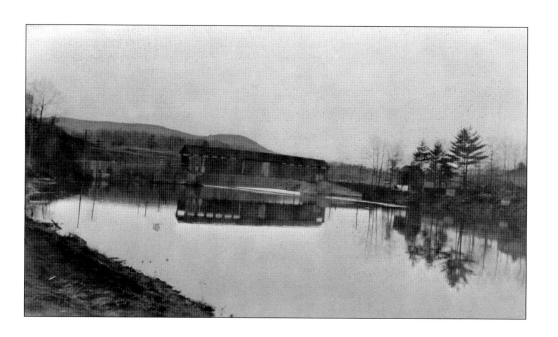

Yet another covered bridge that the Deerfield River Valley provided a scenic backdrop for was Scott's Bridge, which connected the towns of Buckland and Shelburne a mile and a half west of Shelburne Falls village. This bridge was built in 1828 and lasted until 1913, when it was replaced by a steel structure. The above view was taken from the bank of the river, while below offers a bird's-eye perspective of the bridge nestled beneath the high rolling hills of the valley on an early–20th century winter day. Note the extensive forest clearing on the hills. (Both courtesy MassHighway Bridge Section archives.)

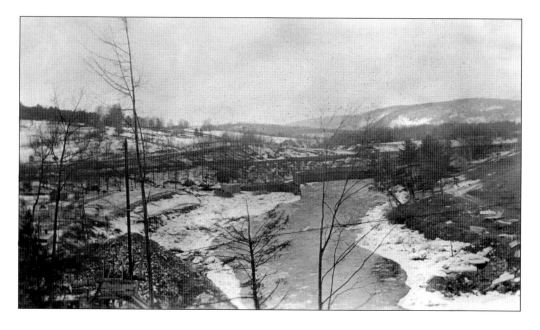

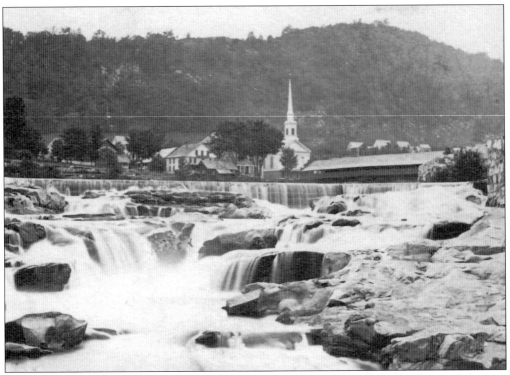

Built in 1821, the covered bridge at Shelburne Falls was one of Massachusetts's first roofed spans. In this *c.* 1850 stereoscope view, it is visible to the right of the village church above the falls of the Deerfield River. The bridge was replaced by an open structure in 1869. The river's falls and glacial potholes have long been attractions of this popular artisan's village. (Courtesy Peter Miller.)

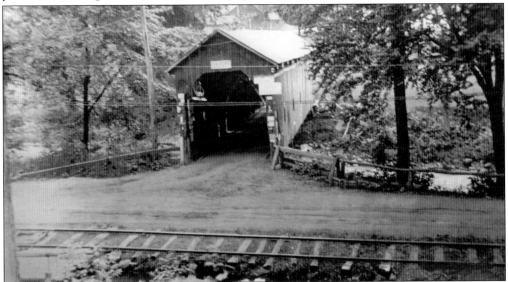

The covered bridge at Griswoldville, a mill village of Colrain, was located on the road to Heath. This 106-foot bridge was built in 1870 and supported traffic until it was destroyed by the floods of March 1936. Note the trolley tracks in the foreground. At the time of its demise, the structure was in considerable disrepair with damage to the floor and sides. (Courtesy Judy Sullivan, Colrain Town Hall.)

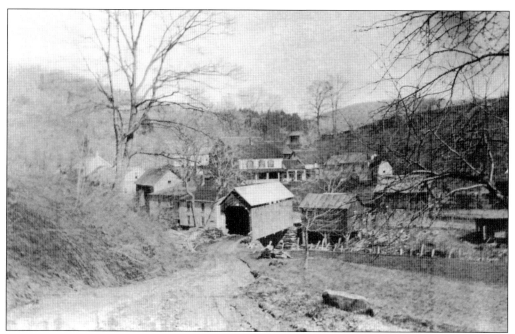

This diminutive covered bridge crossed the West Branch of the North River at Colrain's village of Adamsville. Though it was once an active neighborhood with a large inn, blacksmith shop, gin mill, and school, today only one building from this image remains. (Courtesy Judy Sullivan, Colrain Town Hall.)

At a mere 50 feet in length, the Adamsville Bridge was the shortest covered highway bridge on record in Massachusetts. Here its portal peeks out from behind Brown's Store on a wintry early–20th century day. The bridge was destroyed by the extensive floods of March 1936. (Courtesy Judy Sullivan, Colrain Town Hall.)

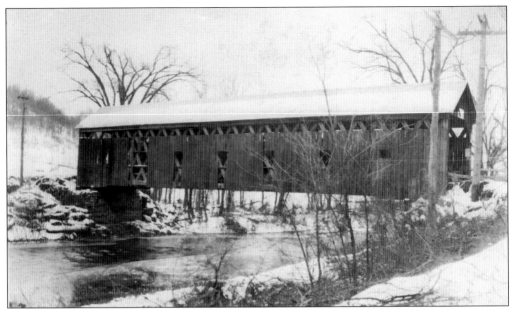

Among the northernmost of Massachusetts's covered bridges was Colrain's Elm Grove Bridge, which was situated 2 miles south of the Vermont state line. This 89-foot-long structure was built in 1871 at a remote location where Franklin Hill Road crossed the North River. Thanks to the light traffic, it suffered less wear than other covered bridges, but was destroyed by the 1938 hurricane floods. (Courtesy MassHighway Bridge Section archives.)

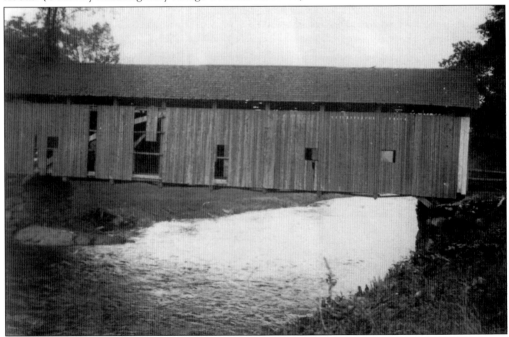

The Hugh Thompson Bridge, which crossed the east branch of the North River on state highway 112 just south of the Vermont state line, was one of a dozen covered bridges that were built in Colrain. While most were lost to the floods of the 1930s, this structure was replaced around 1900 by an open bridge. (Courtesy MassHighway Bridge Section archives.)

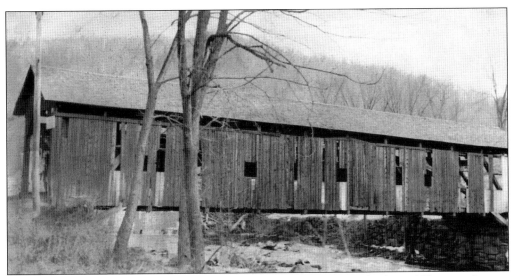

The 112-foot Willis (or Willetts) Place Bridge, seen here in 1921, was built in 1870 across the east branch of the North River at Colrain's Foundry Village on the road to Lyonsville. With its red sides and red-and-white portals, it resembled the nearby Arthur Smith Bridge. It survived the 1936 floods, but was destroyed by the 1938 hurricane. (Courtesy MassHighway Bridge Section archives.)

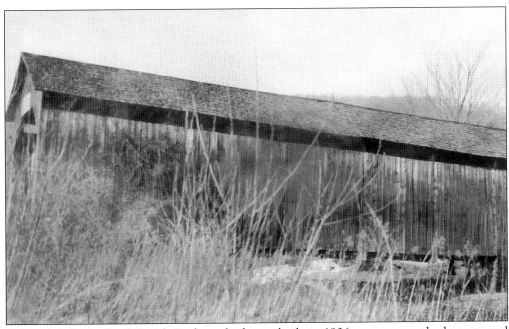

Colrain's Lyle (or Lyal) Smith Bridge, which was built in 1906, was among the last covered highway bridges built in Massachusetts. It spanned a spillway adjacent the West Branch of the North River near Adamsville. Built with a bowstring truss frame, it served the road to Heath until it was replaced by a box culvert shortly before the 1936 floods. (Courtesy MassHighway Bridge Section archives.)

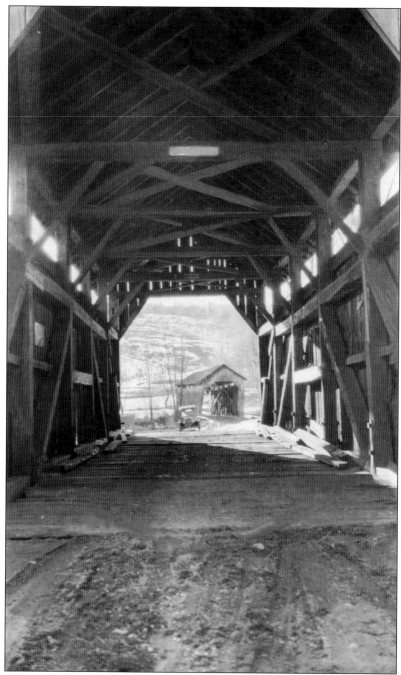

This rare c. 1921 view shows two Massachusetts covered bridges in the same frame. In the foreground is the Frank Herzig Bridge, named for the operator of a nearby mill. This relatively short 58-foot structure featured a five-panel Howe truss frame. Visible through the portal in the background is the Lyle Smith Bridge. These bridges crossed the west branch of the North River in Colrain on the road from Adamsville to Heath. After the 1936 floods, a concrete frame bridge replaced the Herzig Bridge, while a steel beam and concrete deck structure was erected on the site of the former Smith Bridge. (Courtesy MassHighway Bridge Section archives.)

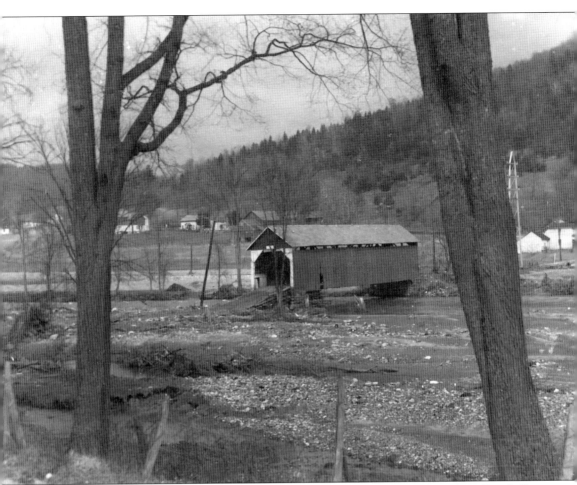

A 1939 view of Colrain's Arthur Smith Bridge looks west across the riverbank to the rolling hills of the North River Valley. In the wake of the 1938 hurricane, it was the town's only remaining covered bridge out of the dozen that once spanned the North River and its tributaries. The sweeping effects of the 1936 and 1938 floods on the North River's floodplain are quite evident here. This bridge owes its durability and longevity in large part to a series of renovations during the 1920s, including the addition of an arch to its Burr truss frame and metal rods. These measures allowed the structure to survive the storms of 1936 and 1938, along with lesser events in 1948 and 1950, in fairly good order. It received another round of repairs in 1956. (Photograph by William Maxant; courtesy Harvard Historical Society.)

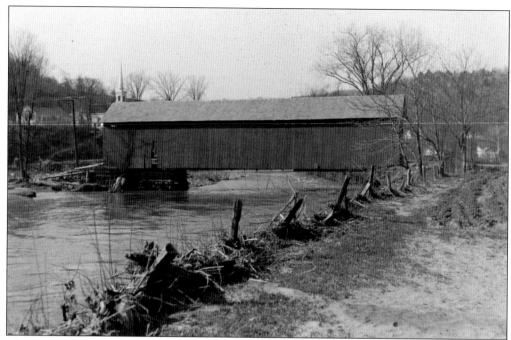

This upstream view of the Arthur Smith Bridge was taken in 1939, and the church steeple at Lyonsville is visible in the background. Given the extent of the floods, the bridge looks to be in good condition, with damage evident on only a few boards. (Photograph by William Maxant; courtesy Harvard Historical Society.)

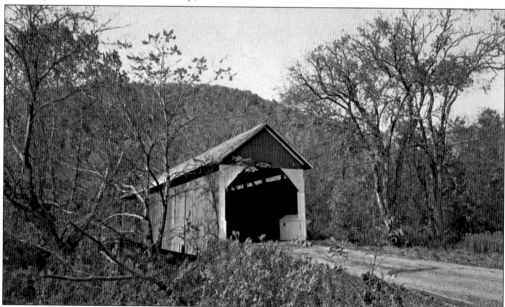

The Arthur Smith Bridge was originally built across the North River between the villages of Shattucksville and Griswoldville, where it was known as the Fox-Temple Bridge. In 1896, it was dismantled and rebuilt at its present location in Lyonsville, where it was renamed after Arthur Smith, a former Civil War army captain who lived near the bridge site. (Courtesy Erving Public Library.)

Judy Sullivan, who has served as Colrain's town clerk since 1969 and contributed several images and information about the town's bridges to this project, poses with her horses outside the revitalized Arthur Smith Bridge's west portal in 1961. The bridge remained in service to vehicles until 1981. (Courtesy Judy Sullivan, Colrain Town Hall.)

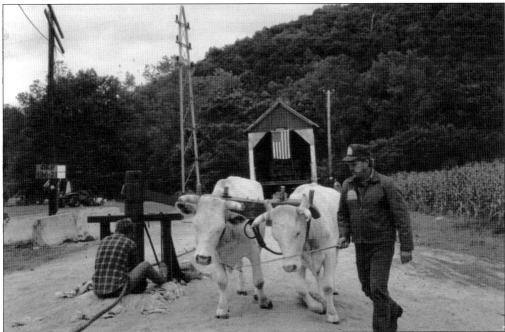

After the Arthur Smith Bridge fell into considerable disrepair during the late 20th century, Arnold Graton and several teams of oxen moved the battered structure to cribbing in a cornfield along the river bank during September 1991, where it remained for 15 years while funds were sought for its restoration. (Courtesy Judy Sullivan, Colrain Town Hall.)

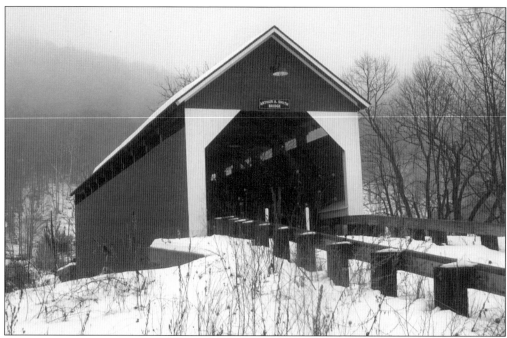

Looking much like its predecessor did for more than a century, the rebuilt Arthur Smith Bridge was finally completed in 2006 using some timbers from the original bridge. In official records, this structure is considered a new bridge, distinct from the historic one that was dismantled, though the original design was retained. The bridge remains closed to traffic, but open for visitors to explore. (Photograph by author.)

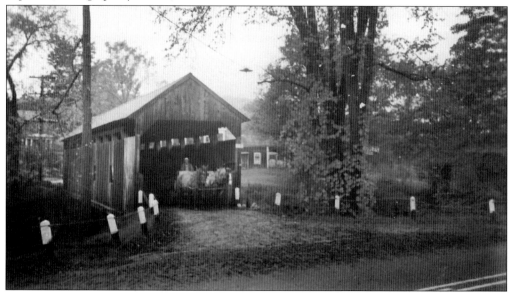

The covered bridge at Conway's village of Burkeville in central Franklin County has been an attraction for travelers to the Connecticut Valley hill towns for nearly 150 years. It is one of four remaining historic covered bridges in Franklin County. Here a horse and buggy emerges from the north portal and heads for the present state highway 116. (Courtesy Harvard Historical Society.)

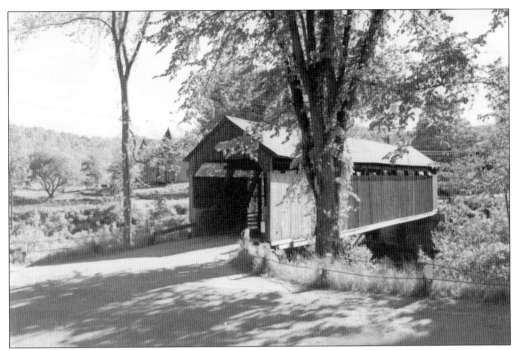

The Burkeville Bridge was erected in 1870 across the narrow South River at Poland Road. The 106-foot, single-span structure was built with a variation Howe truss frame, a design that was popular worldwide during the Civil War years. The long, narrow opening immediately below the roof allowed for some natural lighting of the dark structure. (Courtesy Peter Miller.)

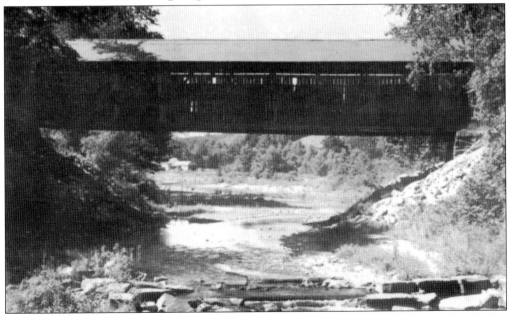

A nearly dry South River courses beneath the Burkeville Bridge. From headwaters in Ashfield, this scenic 12-mile-long waterway meanders through the hills of Conway en route to its confluence with the Deerfield River. Its low volume relative to other Franklin County rivers has helped the bridge survive for more than 140 years. (Courtesy Peter Miller).

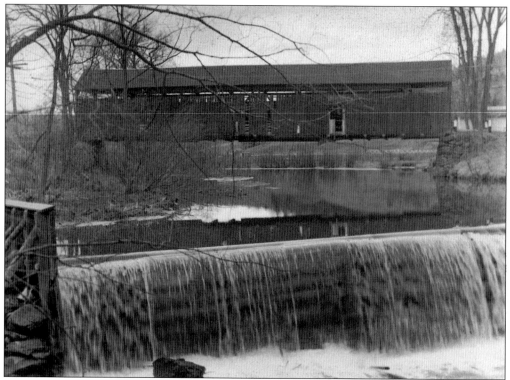

A downstream perspective of the Burkeville Bridge in 1939, as viewed from the falls of the nearby millpond dam along the South River, is seen here. The bridge was damaged by the 1938 hurricane, but remained open to restricted traffic after the roads in the vicinity were rerouted. Some damage to the boards is evident in this image. (Photograph by William Maxant; courtesy Harvard Historical Society.)

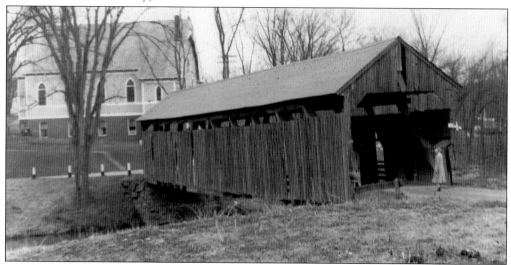

Another 1939 view of the Burkeville Bridge by William Maxant, taken from the south bank of the river, shows his wife, Helen, in front of the portal. The other landmark of the village—the historic Catholic church—is visible here behind the bridge on the opposite side of the state highway. (Courtesy Harvard Historical Society.)

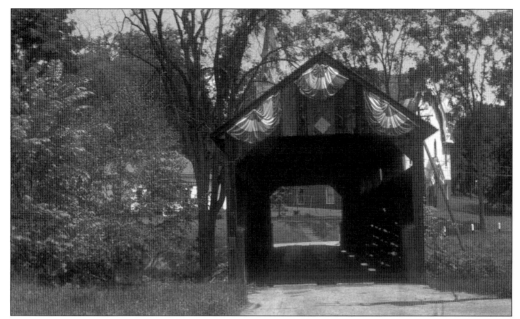

The Burkeville Bridge was given this decorative bunting in honor of Conway's bicentennial celebration in 1967. Some 20 years later, it received its own recognition when it was designated as a National Historic Landmark in 1988. In spite of its deteriorating condition, it remained open to restricted traffic until 1983, when a long saga regarding its restoration began. (Photograph by C. John Burk.)

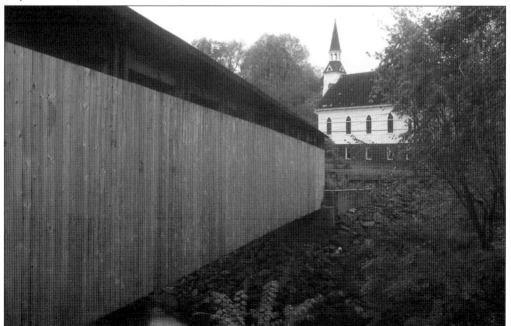

The restoration of the Burkeville Bridge was plagued by a series of delays capped by a contractor abandoning the project during 2000. After sitting in disrepair for more than 20 years, the bridge was finally renovated during 2004 and 2005 by Stan Graton's 3G Construction. The revitalized structure was elevated slightly and given a new floor and cedar-shingle roof. (Photograph by author.)

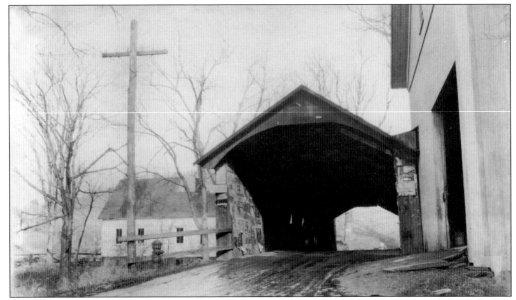

The last remaining covered bridge along the Westfield River was Cummington's Village Bridge, which was located along the road to Plainfield. Built in 1876, this 95-foot-long span was another casualty of the 1938 hurricane. This view of the north portal shows a smattering of advertisements. (Courtesy MassHighway Bridge Section archives.)

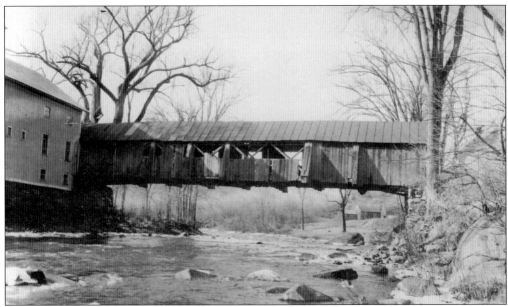

Seen here is a downstream view of the Village Bridge from the banks of the Westfield River in 1928. Visible on the left is a portion of the adjacent church. At the time of its demise, the Village Bridge was, along with the Hockanum Bridge in Hadley, one of only two remaining covered bridges in Hampshire County. (Courtesy MassHighway Bridge Section archives.)

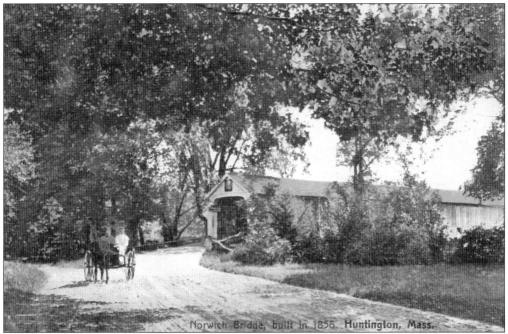

Another of the numerous covered bridges in the Westfield River Valley was the Norwich Bridge in Huntington, which was built in 1856 across the river's West Branch. In a classic early–20th century scene that depicts the rural simplicity for which covered bridges are often identified, a horse and buggy exit onto a country road. In 1994, the town used an image of the bridge on its official flag. (Author's collection.)

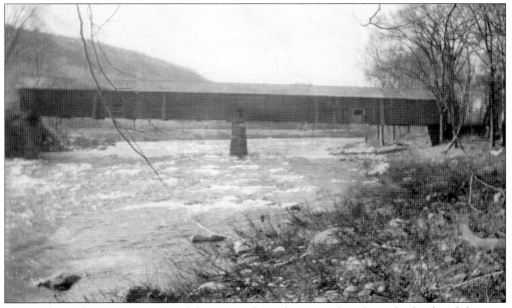

This early–20th century profile of the Norwich Bridge was taken from the banks of the west branch of the Westfield River. With no missing exterior boards or additional supports, the bridge looks to be in fairly good condition here, especially when compared to the image on page 60. (Courtesy MassHighway Bridge Section archives.)

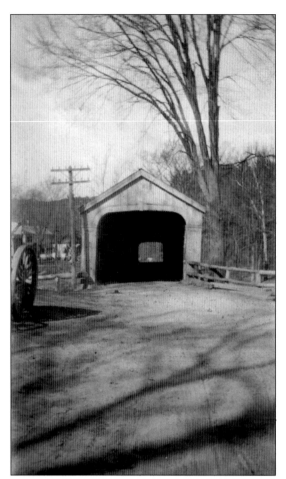

This view into the portal of the Norwich Bridge was taken during a 1921 statewide inventory of bridges in Massachusetts. Three other covered bridges, including a railroad bridge at West Huntington that was lost in 1873 and a structure that was built on private land, are known to have existed in Huntington. (Courtesy MassHighway Bridge Section archives.)

Another 1921 view of the Norwich Bridge shows a series of wooden supports that were added to supplement the center pier. As the visible daylight indicates, there were many missing and damaged boards at the time of this image, and the sagging structure was replaced shortly thereafter. (Courtesy MassHighway Bridge Section archives.)

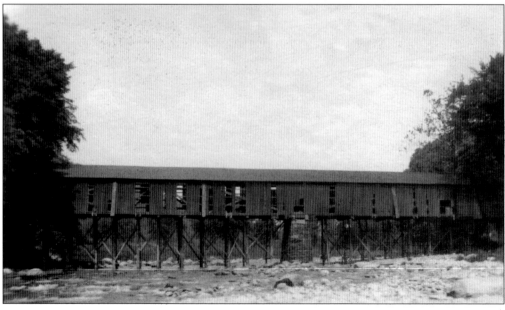

This is an early view of the open concrete span that replaced the Norwich Bridge. In the early 20th century, there was little sentimentality when covered bridges were replaced by modern structures, to the point where records for some bridges are incomplete or vague. However, as these structures became increasingly rare, they have become appreciated for their historic value, and as tourist attractions. (Courtesy MassHighway Bridge Section archives.)

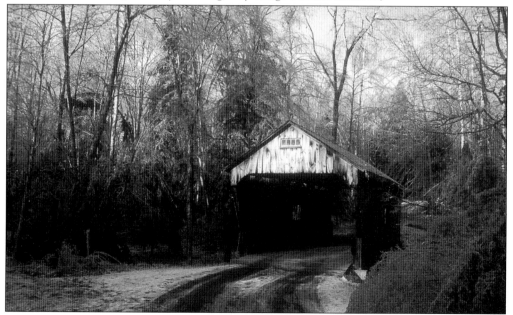

The Creamery Bridge in Ashfield is one of many covered bridges that have been built on private lands and parks in Massachusetts in recent years by individuals and groups with an appreciation for these historic and increasingly rare structures. This 40-foot bridge was built by contractor and sugarhouse operator Dwight Scott in 1985 across Creamery Brook on the family's private driveway. (Photograph by author.)

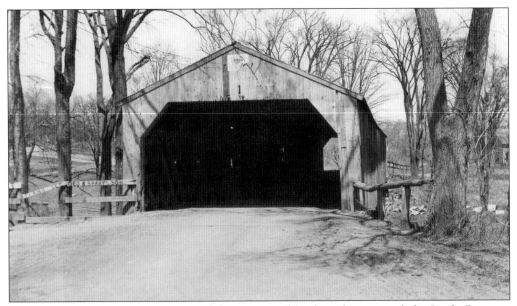

The Cowles Bridge was the oldest of three covered bridges that crossed the Little River in Westfield. Built during the 1820s, it was one of the state's first covered bridges and lasted for nearly a century before being replaced in 1916. In 1864, it was joined by the Upper Cowles Bridge at a nearby crossing of the river. (Courtesy National Society for the Preservation of Covered Bridges archives, Richard Sanders Allen collection.)

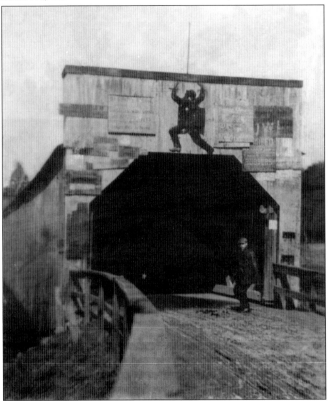

Built in 1835 and distinguished by its unique squared portal, Horton's Bridge was Westfield's second covered bridge across the Little River; it was replaced in 1914. Several other covered bridges in the town crossed the Westfield River, all of which had relatively short life spans during the mid-to-late 19th century. (Courtesy National Society for the Preservation of Covered Bridges archives, Richard Sanders Allen collection.)

Three

THE CONNECTICUT VALLEY

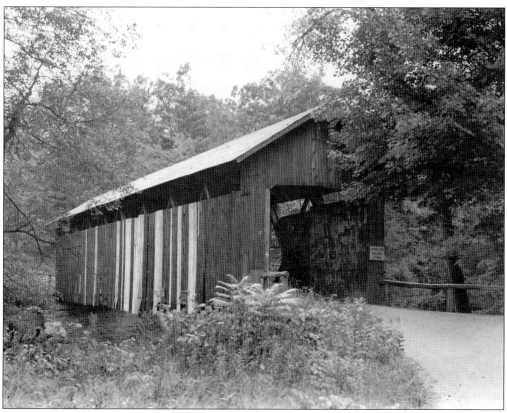

Not to be outdone by the neighboring town of Colrain, Greenfield has hosted 15 covered bridges, several of which were used by railroads. Of these, only the Pumping Station Bridge, which spans the Green River roughly 5 miles northwest of the town center, remains today. There have been two covered bridges built on this site; the original, which was built in 1870 at a cost of $1,460, is shown here in 1939. (Courtesy MassHighway Bridge Section Archives.)

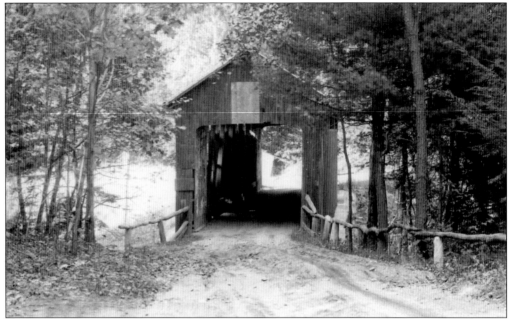

Hidden in Greenfield's northwest corner, the Pumping Station Bridge, also known as the County Farms Bridge, served the narrow Eunice Williams Road, which was named for a Greenfield woman who was kidnapped during an 18th-century conflict with the Mohawk Indians. This view through the portal was taken around 1935. (Courtesy Peter Miller.)

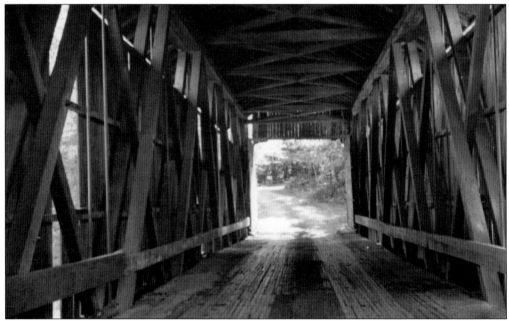

The interior of the original Pumping Station Bridge is seen here. As evidenced by the diagonal X-shaped supports and iron rods, it was another bridge that featured a Howe truss frame. This frame structure was patented by Massachusetts native William Howe in the mid-19th century and today is used in approximately 125 other remaining covered bridges across the country. (Courtesy Peter Miller.)

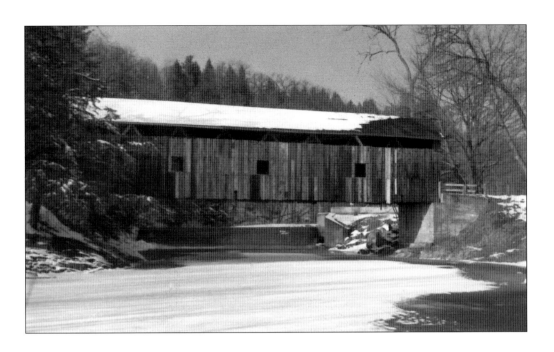

These are two winter views of the first Pumping Station Bridge. The dam adjacent the utility station for which the bridge was named is visible behind the structure in the above image. This locale has long been a popular destination for swimmers and even divers who have jumped off the roof of the bridge. Part of the reason for the bridge's longevity was its location along a relatively quiet segment of the Green River; it was built a mile downstream from an area that had been especially prone to flooding, where several previous 19th-century bridges had been washed out. (Both courtesy Peter Miller.)

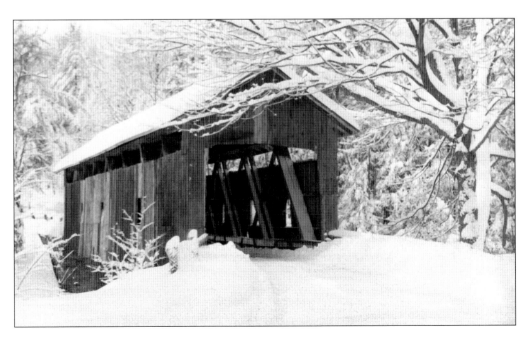

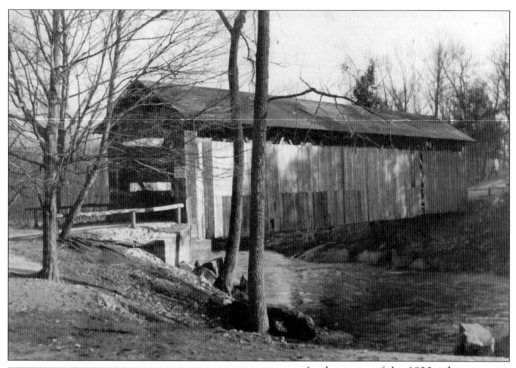

At the onset of the 1930s, there were five remaining covered bridges in Greenfield. By 1939, when this image was taken, the Pumping Station Bridge was the sole survivor, as the others were replaced or lost in the great storms. Only a handful of Franklin County's covered structures survived the decade, and Charlemont's Long Bridge and the East Deerfield Yard Bridge were replaced shortly thereafter. (Photograph by William Maxant; courtesy Harvard Historical Society.)

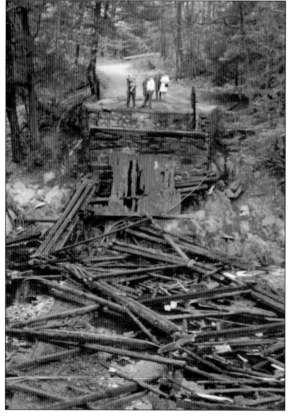

On Halloween 1969, just a few months short of its centennial anniversary, the Pumping Station Bridge was destroyed by three arsonists. It was the second of three historic Massachusetts covered bridges lost in this manner in the late 20th century, along with the Sheffield Upper and Hadley Hockanum Bridges. Here the remains of its timbers lie in the bed of the Green River. (Courtesy Peter Miller.)

Many Greenfield residents were angered by the burning of the Pumping Station Bridge, and a replacement was quickly commissioned by the town and dedicated in 1972. The work was done by the Davenport Company. The rebirth of the bridge was documented by Greenfield town historian Peter Miller. (Photograph by Peter Miller.)

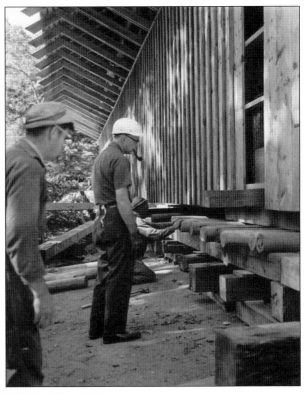

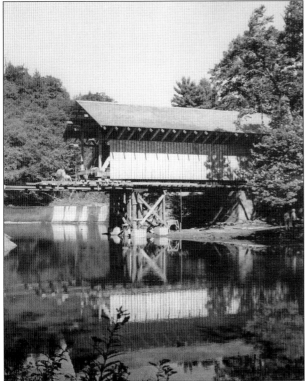

Still partially atop its cribbing, the new Pumping Station Bridge nears its completion. This method allowed the work to be safely completed with adequate support, while also facilitating the movement of the completed structure to its permanent supports on the riverbank. (Photograph by Peter Miller.)

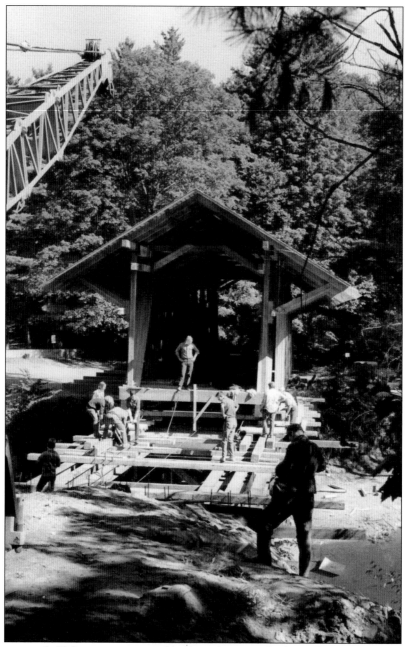

In contrast to mid–20th century covered bridges that were built at Sheffield, Charlemont, and Pepperell, the Greenfield town selectmen mandated that the new Pumping Station Bridge be built largely to the specifications of the original. The new bridge's Howe truss frame exactly matched its predecessor, and it remained a single-span, 94-foot-long structure. However, there were two notable differences motivated by safety. The sides of the new bridge's roof extended much farther down than that of the first bridge. A pedestrian walkway with its own portal was also added to the north side of the new bridge, offering safe access for pedestrians with fine views upstream. During its construction, a portion of the new bridge was built on land, while the other half sat atop temporary cribbing in the river. (Photograph by Peter Miller.)

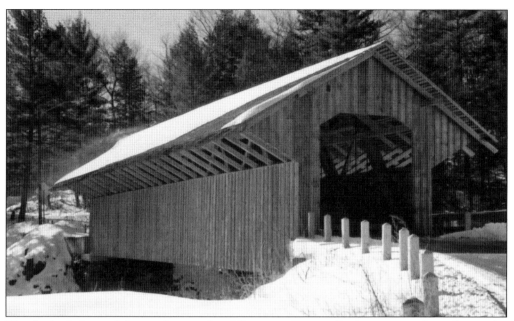

The fresh timbers of the newly completed Pumping Station Bridge are seen here during the bridge's first winter in 1972. The longer roof is evident in this view. The replacement bridge was opened to traffic until being closed in 2003 after inspectors noted considerable warping and deterioration of the structure that may have been caused by trucks violating the posted weight limit. (Courtesy Peter Miller.)

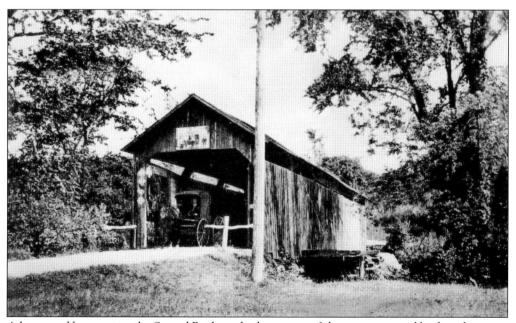

A horse and buggy exits the Smead Bridge, which was one of the seven covered bridges that once spanned the Green River in Greenfield. The bridge connected Colrain Street and Riverside Drive. It was built in 1870 at the onset of a decade when many other covered bridges were erected in Franklin County and the rest of Massachusetts. (Courtesy Peter Miller.)

This side view of the Smead Bridge shows a rather unkempt patchwork of sideboards that exemplified the disrepair many of the area's covered bridges had fallen into by the early to mid–20th century. The bridge was located adjacent the present site of the Davenport Trucking Company. (Courtesy Peter Miller.)

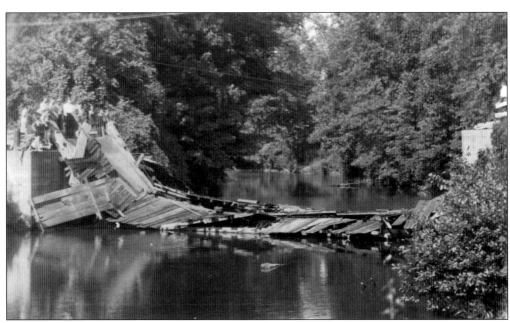

Like many of the state's covered bridges, the Smead Bridge was lost during the 1930s, but its fate was unique: After surviving the floods of 1895 and 1927, it met its sudden end in August 1932, after a crossing by a town truck caused the structure to collapse into the Green River. (Courtesy Peter Miller.)

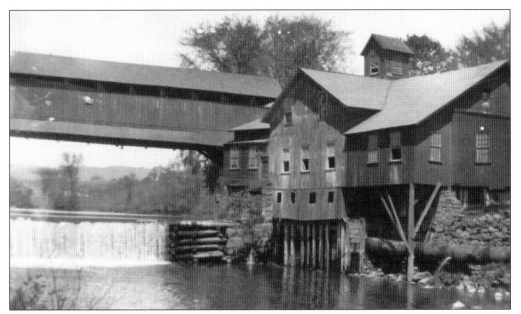

Greenfield's Mill Street Bridge, shown here around 1900, was also known as the Gristmill Bridge, as it was located adjacent to a mill that had operated along the Green River since 1714. This bridge was built in 1869, replacing a previous structure that had stood from 1853 to 1869 on the same location. (Courtesy Peter Miller.)

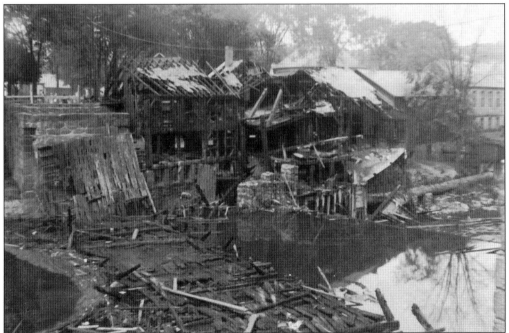

In May 1910, a dozen fires, fanned by 40-mile-per-hour winds and dry conditions, caused considerable damage throughout Greenfield. The covered bridge and the gristmill on Mill Street were both casualties of this inferno. The remains of the bridge and one of its stone supports are visible on the left-hand side of the image. An open concrete bridge was built as a replacement. (Courtesy Peter Miller.)

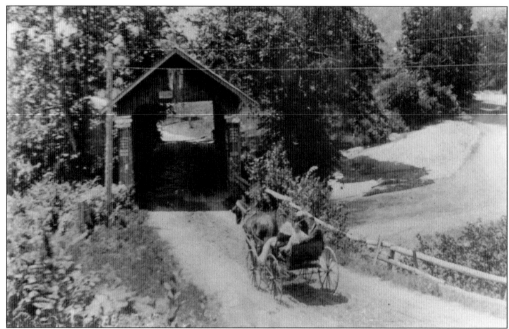

A horse and buggy carriage enters the portal of Greenfield's Nash's Mill Bridge, which spanned the Green River at the mouth of Mill Brook. This bridge was erected in 1870 and served for more than 60 years until it was dismantled in 1934, the same year that the nearby Cheapside Bridge was also replaced. (Courtesy Peter Miller.)

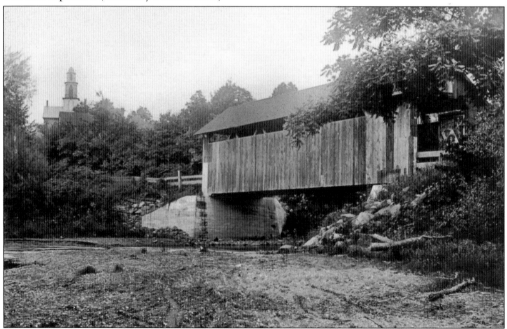

This is a side view of the Nash's Mill Bridge from the banks of the Green River. The structure was a short distance east of a swimming pool. The bulk of the town's covered bridges crossed this scenic tributary of the Deerfield River, whose headwaters are a short distance across the state line in the hills of southern Vermont. (Courtesy Peter Miller.)

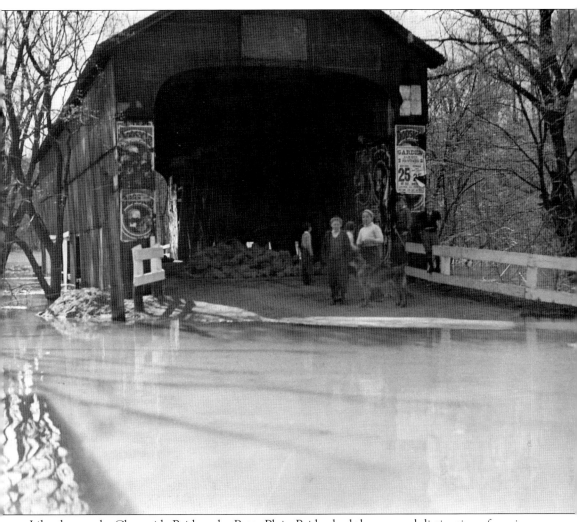

Like the nearby Cheapside Bridge, the Petty Plain Bridge had the unusual distinction of serving two towns over its lifetime without being moved, as it was built in 1871 in a neighborhood in Deerfield that subsequently became a part of Greenfield. It provided a heavily used crossing of the Green River that provided access to the town's athletic fields and was thus also known as the Ball Park or Lower Bridge. In this view, a group of children gather in front of its portal as water inundates the structure during the onset of the 1936 flood. Behind them is a large pile of sandbags that was set up in an attempt to stabilize the structure. Plastered on both sides of the entrance are advertising posters from a popsicle maker. The bridge was located in an especially flood-prone area just above the Green River's confluence with the broad Deerfield River, whose floodwaters often backed upstream past the bridge site. (Courtesy Peter Miller.)

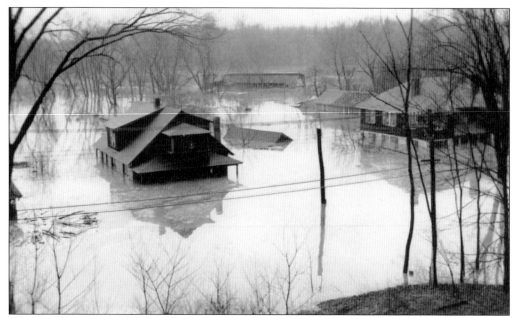

Along with the Pumping Station and Montague City Bridges, the Petty Plain Bridge was one of the last covered bridges remaining in Greenfield. After years of wear it was finally destroyed by the 1936 floods. In this image, the structure, visible behind the inundated homes in the foreground, has been washed completely off its supports. (Courtesy Peter Miller.)

Greenfield's Wiley and Russell Bridge was the subject of this distinctive postcard. It was named for the Wiley and Russell Company, a manufacturer of thread-cutting tools that operated an adjacent mill on the Green River. The bridge was replaced in 1917, five years after the mill was acquired by the Greenfield Tap and Die Company. (Courtesy Peter Miller.)

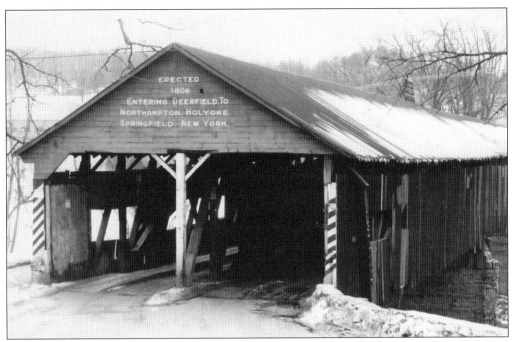

Though the portal of the Cheapside Bridge read, "Erected 1806 / Entering Deerfield. To / Northampton. Holyoke. / Springfield. New York," this structure was actually built in 1826 as one of the state's earliest covered bridges. Its somewhat unfortunate moniker reflected its location in a low-income area that was originally part of Deerfield and subsequently annexed to Greenfield. Cheapside was the site of an active river port with large storehouses that was a central part of Greenfield's early history. It was used by steamboats, railroads, and trolleys before declining, following the advent of the automobile. (Above, courtesy Peter Miller; below, courtesy MassHighway Bridge Section Archives.)

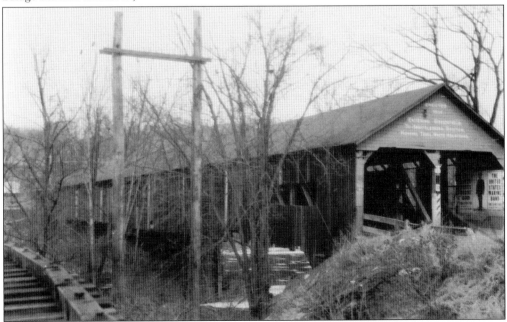

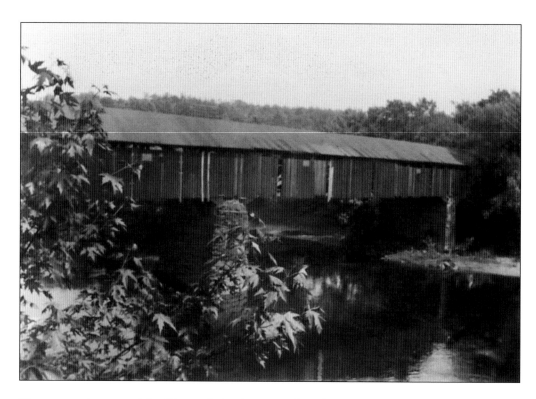

These two side views of the Cheapside Bridge were taken during the summer and winter of 1927, the year after the bridge's centennial. The hefty central pier in the bed of the Deerfield River provided support for the bridge's twin spans. The stone abutments that once supported the structure along both banks of the river are still present and visible today, as the replacement bridge was built a short distance to the west. The bridge was built on the site of a well-known massacre that occurred during a conflict between English settlers, the French, and Native Americans in 1704. (Both courtesy MassHighway Bridge Section Archives.)

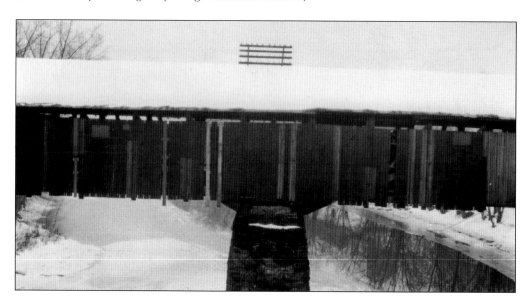

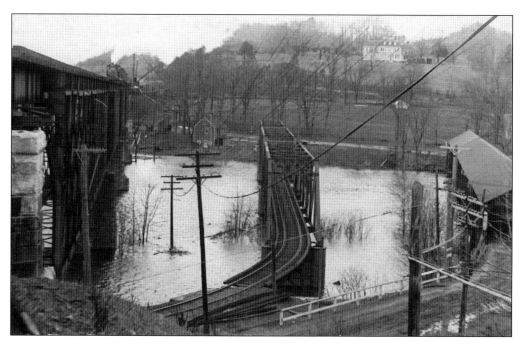

Cheapside was well known for its photogenic trio of bridges that served the busy river port. The highest structure was the railroad bridge. Trains are depicted in both images; look carefully for the locomotive's plume of smoke in the top image. The smaller and lower middle bridge was part of a trolley line. The covered bridge, visible on the right margin of the above image and on the left of the one below, was used by pedestrians, horses, and automobiles. The above picture was taken from the Deerfield (west) side of the river, the view below is from Greenfield (east). (Courtesy Peter Miller.)

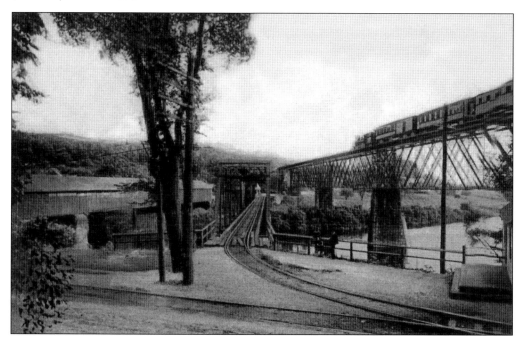

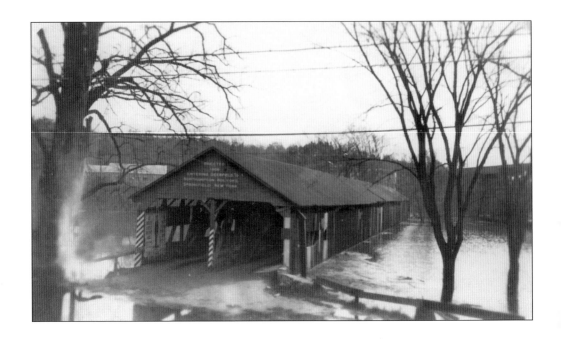

High waters from the floods of November 1927 press in on the Cheapside bridges. Though this storm did not affect Massachusetts as severely as those of the late 1930s, it caused a great amount of damage in neighboring Vermont, where heavy rains persisted for several days. A remarkable total of roughly 200 of Vermont's covered bridges were washed out over a two-day period. There were countless unusual incidents, including dislodged bridges colliding into each other and dropping over falls as they floated downstream; others somehow were deposited into fields in good enough condition that they were successfully rebuilt. (Courtesy Peter Miller.)

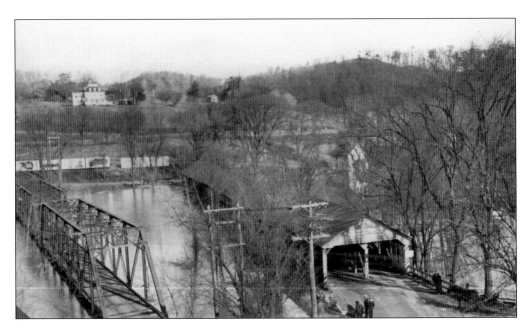

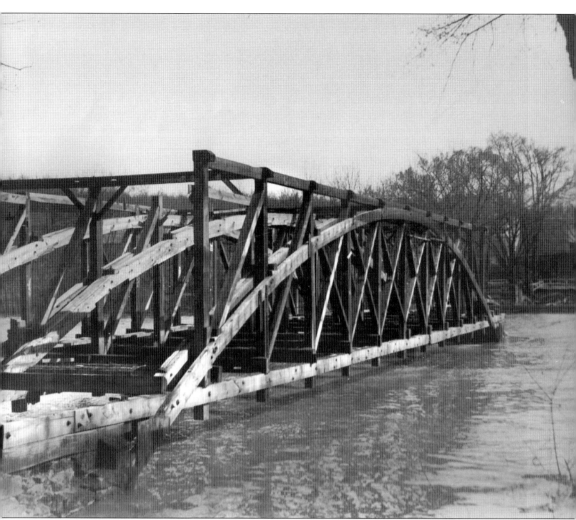

Unlike many of the younger Franklin County bridges that were lost in the floods of the 1930s, the Cheapside Bridge was simply deemed obsolete by 1932. It was subsequently dismantled in 1934 and replaced by an open bridge. This view of the structure's teardown offers a good view of the Howe truss frame and reinforcing arches on one span; the second has been completely removed. After it was removed, some of the bridge's boards were used in the construction of a house in nearby Shelburne Falls, and others were made into chairs at the Greenfield Historical Society. At the time of its loss, it was one of only two remaining bridges over the Deerfield River in Massachusetts; the Long Bridge in Charlemont was dismantled in 1944. (Courtesy Peter Miller.)

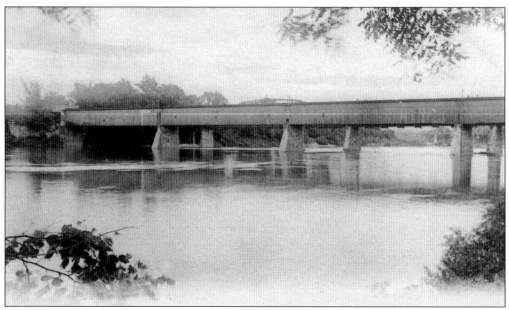

One of the most distinctive covered bridges in Massachusetts was the massive, 863-foot structure that connected Greenfield to Montague City. It was equal in size to the Palmer and Rocks Village Bridges in Haverhill and more than twice as long as the Old Toll Bridge in Springfield and Charlemont's Long Bridge. Note the good condition of the exterior in this c. 1900 view. (Courtesy Peter Miller.)

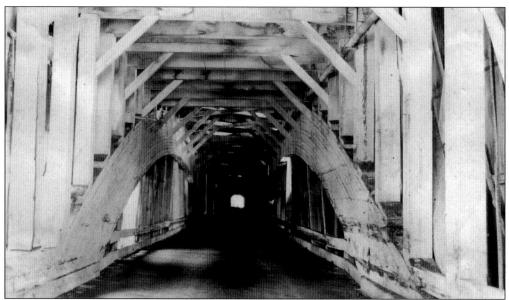

This 1928 view looks into the long, dark tunnel of the Montague City Bridge, which was comprised of three 158-foot spans and single spans of 135 and 163 feet. Throughout its quintet of spans, a Howe truss frame with ribbed arches combined to support this hefty structure. Snow was spread along the interior floors to allow heavily loaded sleds and sleighs to make the crossing in winter. (Courtesy MassHighway Bridge Section archives.)

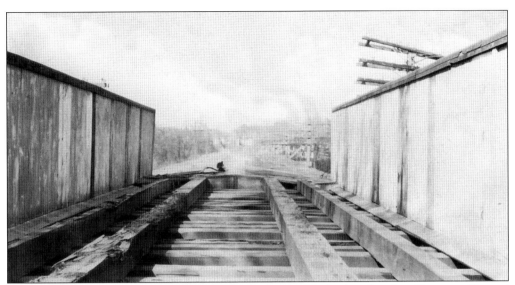

The Montague City Bridge was a combination bridge used for both railroad and horse-and-buggy/vehicle traffic. The railroad tracks, which were operated by the Boston and Maine Railroad, crossed the roof of the structure, and the passage of a train overhead often made for a frightful crossing for horses and pedestrians who happened to be using the bridge at the same time. (Courtesy MassHighway Bridge Section archives.)

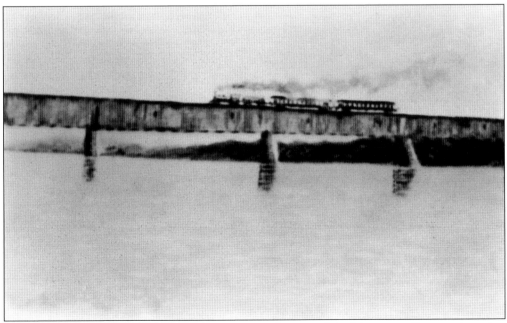

This is the only known image of a train crossing the top of the Montague City combination bridge. Supports were added in 1901 to help the structure sustain the additional weight and stress created by the railroad. One advantage to running the trains across the roof was that their smoke would not accumulate in the interior. The rooftop crossing was discontinued in 1921. (Courtesy Peter Miller.)

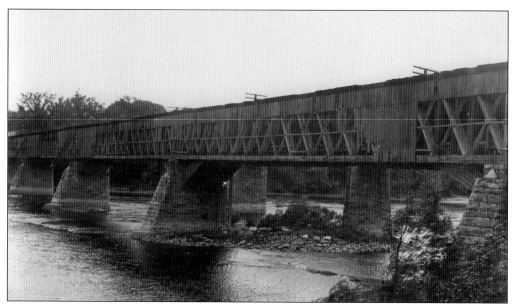

The Montague City combination bridge was supported by high, angular stone piers. As evidenced by the many missing and damaged boards, it had deteriorated substantially by the 1920s, and notes in state bridge records from a 1928 inspection indicated that the bridge was a candidate for rebuilding in 10–15 years. (Courtesy MassHighway Bridge Section archives.)

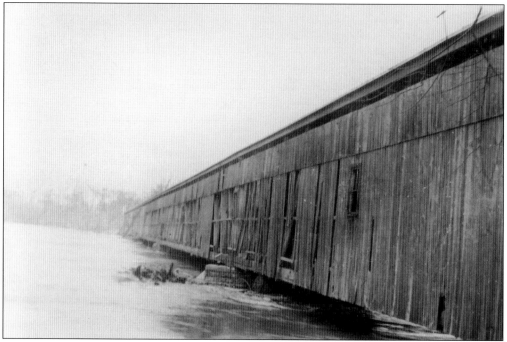

In a precursor to the floods of 1936, a much higher Connecticut River passes closely beneath the floor of the Montague City Bridge during the spring of 1933. Even in years without significant storms, bridges on wide rivers such as the Connecticut, Deerfield, Merrimack, and Housatonic Rivers were stressed by high water annually following the end of winter. (Courtesy MassHighway Bridge Section archives.)

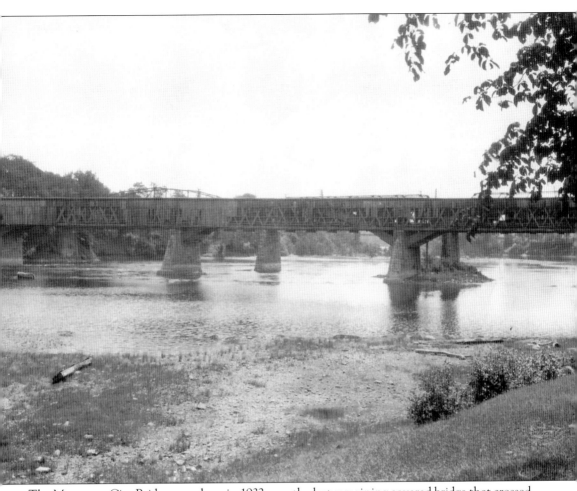

The Montague City Bridge, seen here in 1932, was the last remaining covered bridge that crossed the Connecticut River in southern New England. This wide-angle view amply demonstrates how high the river rose during the floods of 1936. There were at least nine other sites in Massachusetts where covered bridges were built across New England's longest and best-known river. The crossing from Sunderland to Deerfield was especially troublesome, as several structures were built and destroyed between 1832 and 1876. The Northampton-Hadley Bridge, which was more than 1,000 feet long, was destroyed by a tornado in 1877. The state's longest covered bridge on record was the 1,330-foot Western Railroad Bridge, which connected Springfield and West Springfield and included seven 180-foot spans. A well-known, 975-foot toll bridge operated at Hartford, Connecticut, from 1818 to 1895. (Courtesy MassHighway Bridge Section archives.)

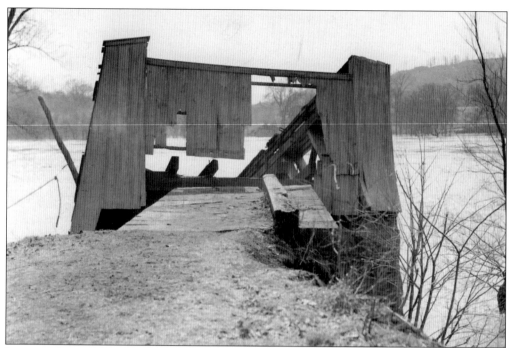

In spite of its size, the Montague City Bridge was no match for the March 1936 floods, which washed the bulk of the bridge off its supports and carried it into the nearby trolley bridge. In the above view, the smashed remains of the Montague portal cling to the riverbank. (Courtesy MassHighway Bridge Section archives.)

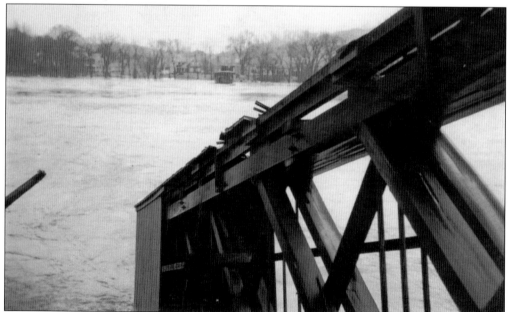

In this view west across the swollen Connecticut River toward Greenfield, a lone segment of the Montague City Bridge's Howe truss frame on the Montague side remains attached to the portal. At the time of its loss, the Montague City Bridge was the largest remaining covered bridge in the United States. (Courtesy Peter Miller.)

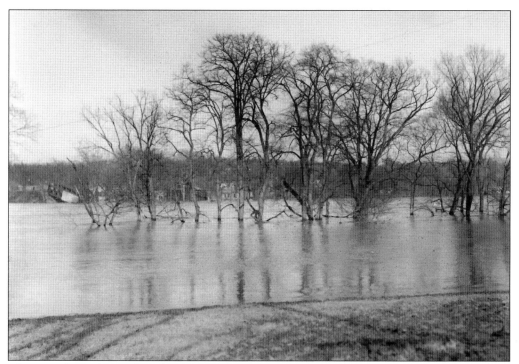

The immediate aftermath of the floods can be seen from the Greenfield side of the river on March 20, 1936. Visible across the river and to the immediate left of the inundated oak trees in the foreground are the remains of the east portal and frame of the Montague City Bridge. (Courtesy MassHighway Bridge Section archives.)

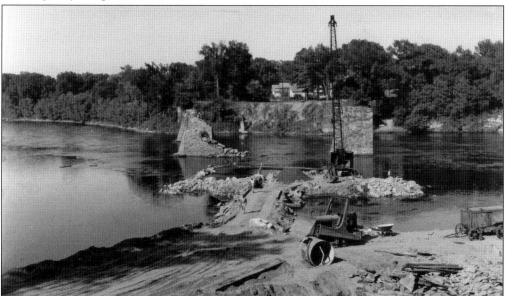

For more than a decade, the battered stone supports of the lost Montague City covered and railroad bridges served as monuments to this historic flood. The covered bridge was ultimately replaced by the steel and concrete Governor Prence Bridge; early construction work during 1947 is shown here. (Courtesy MassHighway Bridge Section archives.)

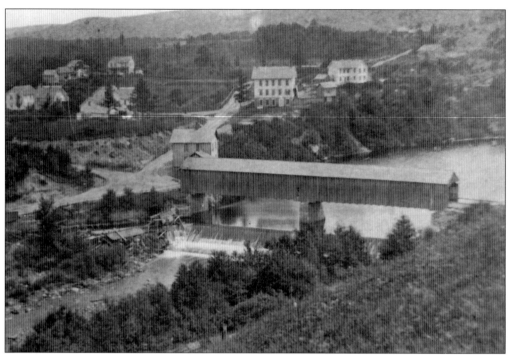

An early-1870s stereoscope view shows the covered bridge near the center of Millers Falls, which is a village of the town of Montague. The top of this structure was damaged by a fire that also destroyed a nearby house. This bridge had a relatively short lifespan, as it was replaced by an open structure in 1892. (Courtesy Erving Public Library.)

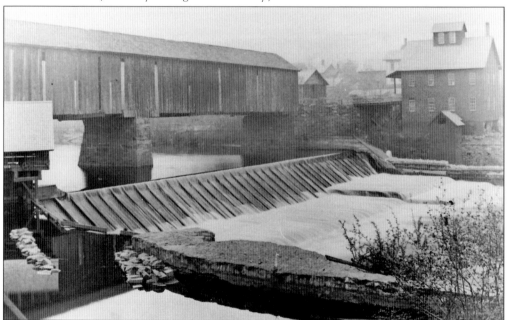

Seen here is a side view of the Millers Falls Bridge showing the adjacent milldam along the Miller's River and the structure's central support. Beginning in 1872, the town of Montague paid a resident a monthly salary of exactly $1 to maintain lights in the bridge. (Courtesy Erving Public Library.)

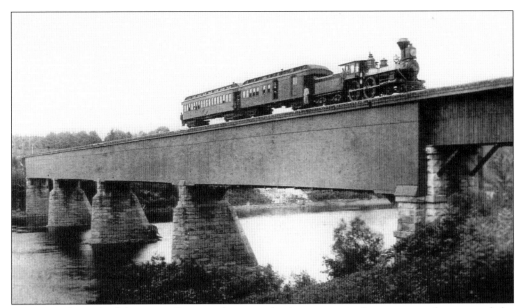

Upstream from the Montague City combination bridge was a similar structure that crossed the Connecticut River west of the center of Northfield. This 810-foot structure was built by Vermont and Massachusetts Railroad in 1848 and dismantled in 1904, following the opening of the Schell Bridge a short distance upstream. Lanterns were mandated for those traversing its long, dark tunnel after nine o'clock each evening. (Courtesy Ashfield Historical Society.)

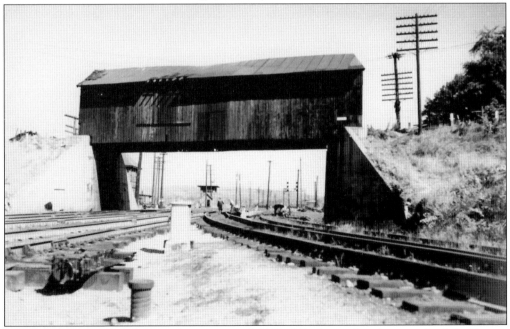

Known locally as McCallen's or the East Deerfield Yard Bridge and in the records of the Boston and Maine Company as "A148," this structure was a rare example of a covered bridge that did not span a waterway; instead it crossed above a series of tracks at the Boston and Maine Railroad Company's East Deerfield freight yard a short distance from the Cheapside Bridge. (Courtesy Peter Miller.)

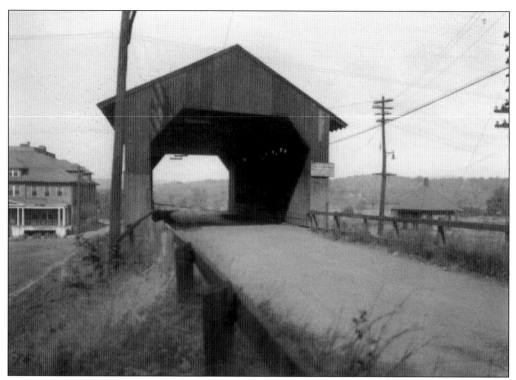

The portal of the East Deerfield Yard Bridge is pictured here around 1930. Erected in 1906, the 74-foot-long structure was one of the last covered bridges to be built along a public route in Massachusetts. It was ultimately dismantled and replaced by an open bridge in 1950. (Courtesy Peter Miller.)

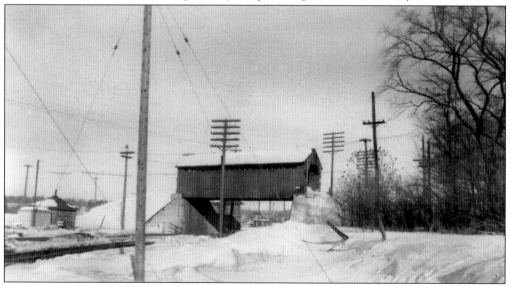

Though Adelbert Jakeman lamented that the East Deerfield Yard Bridge "must bear all day with the hiss of escaping steam, the echo of engine bells and whistles, and the clanking of changing switches" as an overpass bridge, it was thus spared from the ravages of the floodwaters that destroyed or severely damaged many other covered bridges in Franklin County during the 1920s and 1930s. (Courtesy MassHighway Bridge Section archives.)

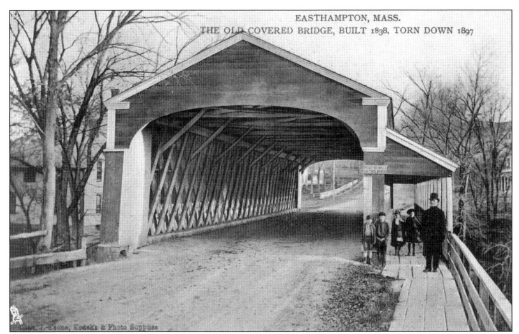

Established in 1838, this covered bridge was the fifth attempt by the town of Easthampton to construct a span over the Manhan River at Northampton Street. The structure was partially paid for by a fund left over from the War of 1812. Visible in this image is the bridge's Town truss frame and pedestrian walkway. (Courtesy Williston Memorial Library, Easthampton.)

Seen here is a *c.* 1890 view from the Easthampton covered bridge. The bridge collapsed in 1897 after a town water main broke and washed out one of the entrances. Though it was patched up and temporarily restored, it was replaced the following year by an iron bridge. A nearby covered bridge over the Mill River at South Street in Northampton was lost to fire on July 4, 1893. (Courtesy Williston Memorial Library, Easthampton.)

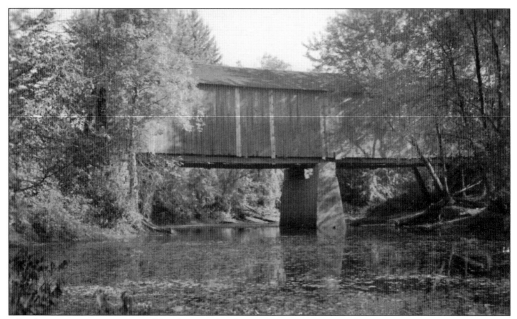

The last remaining covered bridge in the lower Connecticut Valley was the Hockanum (also commonly called Fort River) Bridge, which crossed the Fort River near its confluence with the Connecticut River adjacent the Hockanum Meadows south of the center of Hadley. This two-span structure was built around 1840; the center pier was added in 1923. (Courtesy Harvard Historical Society.)

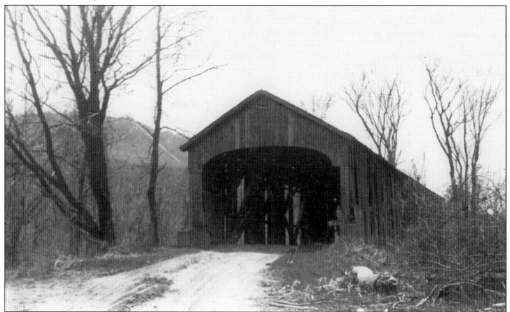

The Hockanum Bridge was located in an especially scenic country setting at the base of the ridge of Mount Holyoke, a familiar landmark of the Connecticut River Valley. Not surprisingly, given its location in a flood-prone area at the confluence of two rivers, the dirt roadway it served was rough, frequently flooded, and often impassable. This view was taken by William Maxant in 1939. (Courtesy Harvard Historical Society.)

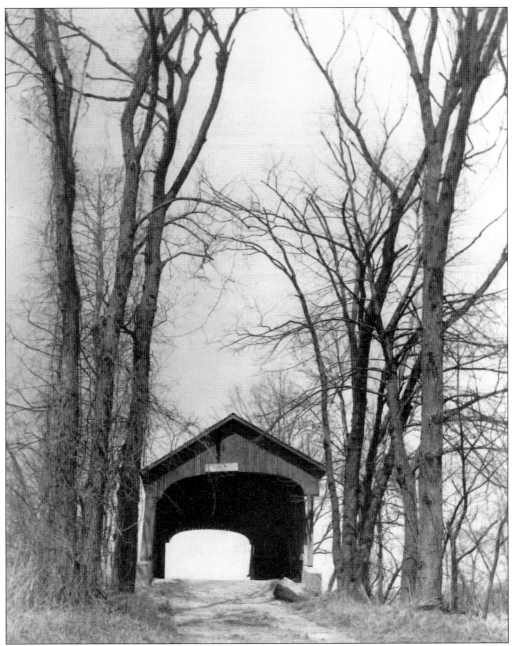

In 1948, an intense cloudburst caused the Fort River to flood with such force that it changed its course and formed a new channel into the Connecticut River a mile north of the bridge. Following the road washout, the abruptly isolated bridge was visited primarily by local fishermen and farmers. One unfortunate cow was cut off from its home and briefly stranded across the river, obliging its owner to undertake a 6-mile journey to escort it back to the barn. This view shows the tall elms that framed the bridge's portal; both the trees and bridge are now gone. With the exception of the Ware-Gilbertville Bridge, half of which is in Worcester County, the Hockanum Bridge was the last remaining covered bridge in Hampshire County and one of only two in the Connecticut River Valley. (Photograph by William Maxant; courtesy Harvard Historical Society.)

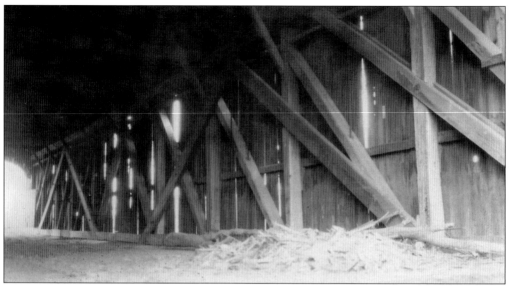

The interior of the Hockanum Bridge, as seen during an inspection by the state bridge division, is pictured here in 1928. In his description of the bridge in *Covered Bridges of the Northeast*, Richard Sanders Allen wrote that "a ghost has been reported on this bridge, and the area is certainly lonesome enough to support one." (Courtesy MassHighway Bridge Section archives.)

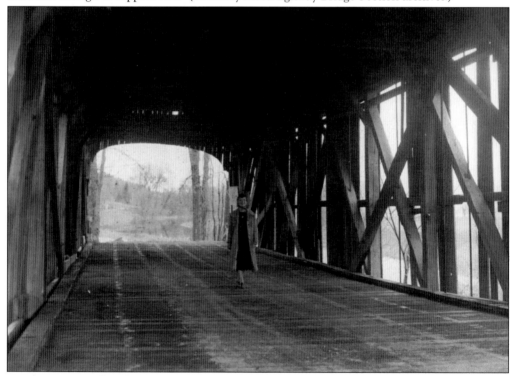

No ghosts are evident here as Helen, wife of photographer William Maxant, strolls through the interior of the Hockanum Bridge during their April 1939 tour of western Massachusetts. Though weather was the primary reason for the numerous damaged or missing boards, others were displaced by vandals. (Courtesy Harvard Historical Society.)

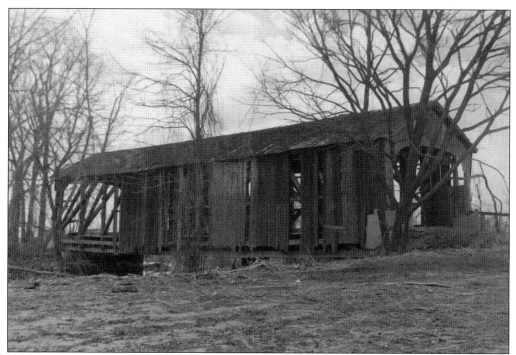

A post-hurricane view of the battered Hockanum Bridge in 1939 was taken from the east side of the structure looking to the west. In spite of its condition, the isolated bridge managed to hang on for more than 20 years before being destroyed by arson on July 2, 1962. (Photograph by William Maxant; courtesy Harvard Historical Society.)

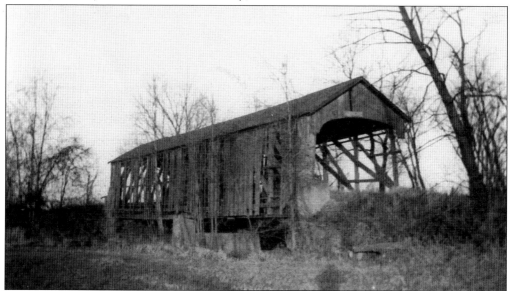

This is another 1939 view of the Hockanum Bridge, taken from the west side of the structure. Unlike the Sheffield Upper and Greenfield Pumping Station Bridges, which were rebuilt in the late 20th century after being burned, no replacement was ever commissioned for the Hockanum Bridge, due largely to its remote location. (Photograph by W. E. Robinson; courtesy MassHighway Bridge Section archives.)

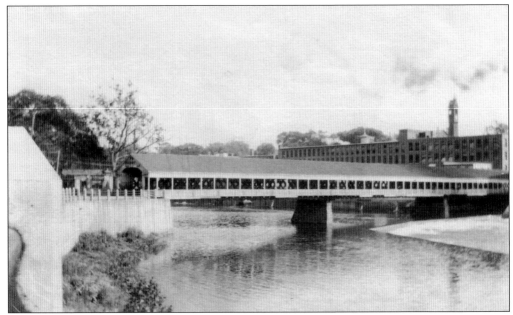

Erected in 1846, the Chicopee Falls Bridge connected Chicopee Center with Chicopee Street and the Granby Road. The A. G. Spalding and Brothers factory is behind the bridge, which spanned a rocky, shallow portion of the Chicopee River known as the "Indian Wading Place." This bridge was destroyed by a fire in November 1903. (Courtesy Chicopee Public Library.)

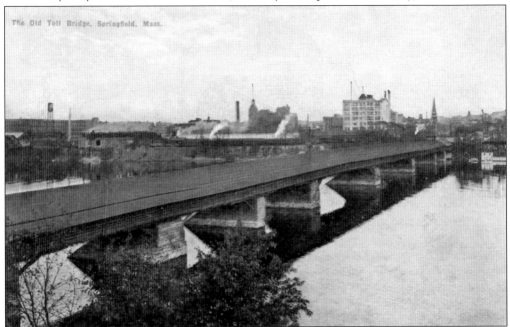

Thanks to its location, size, and presence on numerous postcards, Springfield's Old Toll Bridge, which crossed the Connecticut River between Springfield and West Springfield, is one of the best-known historic bridges in Massachusetts. Built in 1819, it was also known as the Red, Long, or Lottery Bridge, as the $22,000 funds for its construction were raised through the sale of $6 lottery tickets. (Courtesy Jim Boone.)

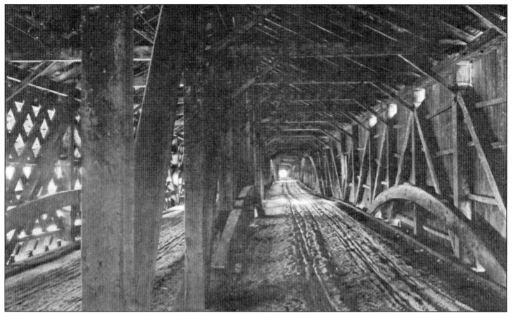

The interior of the Old Toll Bridge is seen here around 1904. Ironically, the Connecticut River helped supply materials for one of its most popular crossings, as the large pine trees that were used in the construction of the arches were floated down the river all the way from the White Mountains of New Hampshire. (Courtesy Jim Boone.)

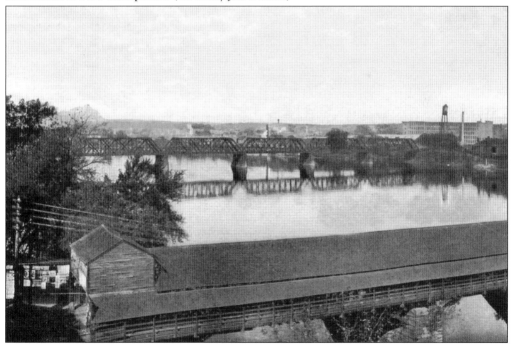

Despite regular predictions of its imminent demise, the Old Toll Bridge survived for more than a century before being dismantled and replaced by the Memorial Bridge. Tolls were collected until July 1872, and a pedestrian walkway was added to the structure in 1878. In the background is the iron railroad bridge that also connected Springfield and West Springfield. (Courtesy Jim Boone.)

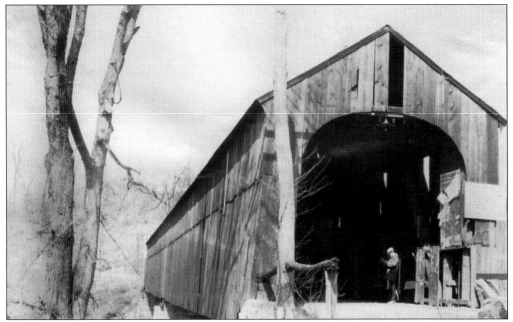

On the east side of the Connecticut Valley, half a dozen covered bridges, including one railroad bridge, were built across the Chicopee River in Ludlow during the 19th century. All but one of these were gone by 1900. The last survivor was the Collins Station Bridge, seen here in 1921, seventy years after its construction in 1851. (Courtesy MassHighway Bridge Section archives.)

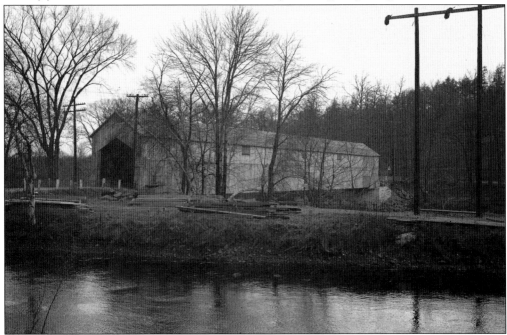

The Collins Station Bridge was originally built as a single-span bridge. In 1878, a center pier was added to provide additional support for the 224-foot structure. It survived the floods of March 1936 with repairable damage and looks in good condition in this November 1937 river-level view. (Courtesy National Society for the Preservation of Covered Bridges, Raymond Brainerd Collection.)

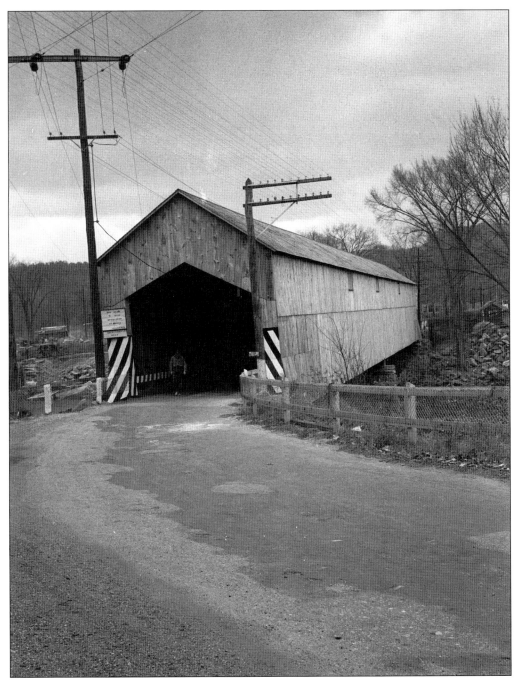

The Collins Station Bridge served a town road a short distance north of the heavily traveled state highway 20, the forerunner to the present Massachusetts Turnpike. Though a 6-ton limit was posted for the bridge, on one occasion it supported the crossing of a 26-ton stone monument with only minor damage. At the time this image was taken in November 1937, it was, along with the Forest Lake Bridge in Palmer, one of two remaining covered bridges in Hampden County and the only one that served traffic. (Courtesy National Society for the Preservation of Covered Bridges, Raymond Brainerd Collection.)

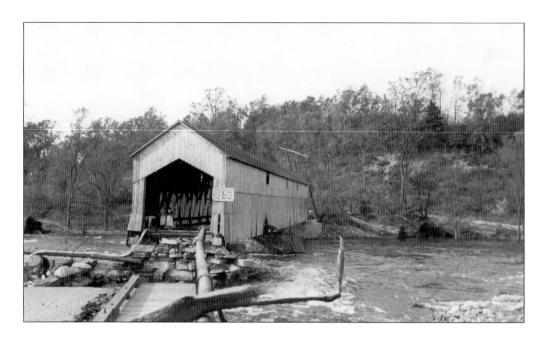

The floodwaters from the 1938 hurricane caused the Chicopee River to breach a dam above the Collins Station Bridge and alter its course. The bridge's supports were washed out, along with the approaches to both portals. In the above view, water for North Wilbraham is being pumped across the river by hose from the reservoir on the Ludlow side. The sideboards on the left-hand side behind the two women have been ripped away, exposing a portion of the frame. Some downed and bent trees are visible along the riverbanks. The bridge was dismantled shortly thereafter and replaced with an open bridge. (Both courtesy National Society for the Preservation of Covered Bridges, Richard Roy and Richard Sanders Allen Collections.)

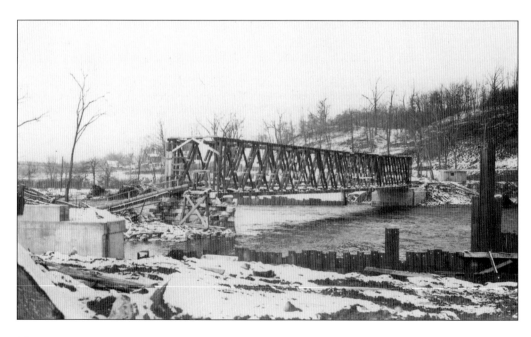

Four

CENTRAL AND EASTERN MASSACHUSETTS

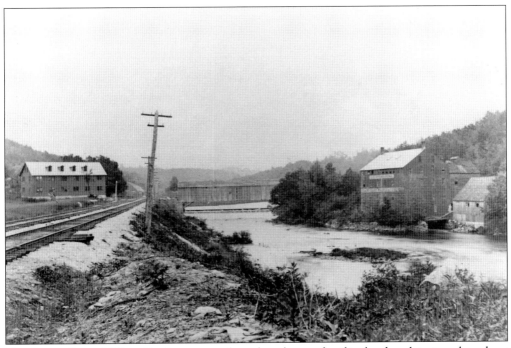

The Erving Paper Mill and its forerunners have long been a familiar landmark to travelers along Route 2 in north-central Massachusetts. In 1857, the towns of Wendell and Erving collaborated to build this 141-foot-long covered bridge over the Millers River adjacent to the mill site. At the time of this 1870 photograph, the buildings were owned and operated by the Stone Company, a renowned manufacturer of piano legs and billiard tables. (Courtesy Erving Public Library.)

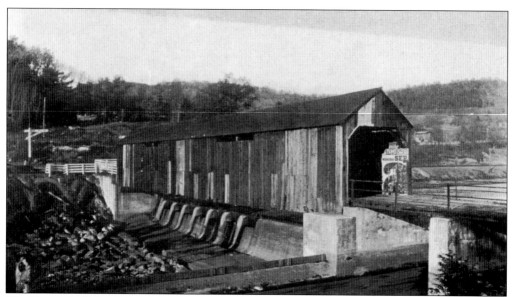

The Erving Mill Bridge is seen in 1910 after roughly a half-century's worth of service. A posted circus advertisement adorns the right-hand side of the portal, and the dried-up Millers River offers a good view of the bridge's supports and the milldam below. The river is one of the region's most active industrial waterways and is the largest tributary of the Connecticut River in central Massachusetts. (Courtesy Peter Miller.)

The great floods of the 1930s disrupted transportation and travel throughout New England. In addition to roads and bridges, many railroad lines that followed river valleys were washed out. Here the tracks behind the Erving Paper Mill lie in a twisted mess near the covered bridge after the March 1936 storm. (Courtesy Dick Chaisson.)

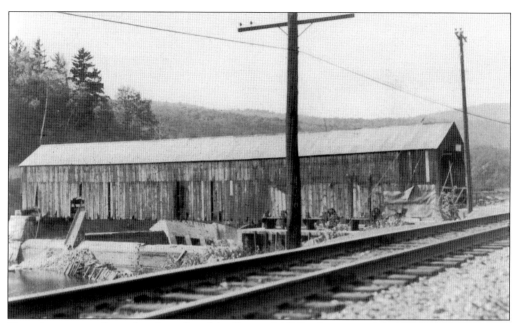

Two views across the railroad tracks of the Erving Mill Bridge were taken in 1936 shortly before the structure was lost in 1938. For its last 30 years, following the replacement of the bridge at West Orange in 1907, the Erving Mills Bridge had the distinction of being the easternmost of Franklin County's numerous covered bridges. At the time of its demise, it was, along with the nearby and similarly ill-fated Partridgeville Bridge in Athol, also one of only two remaining along the Millers River. (Both courtesy MassHighway Bridge Section archives.)

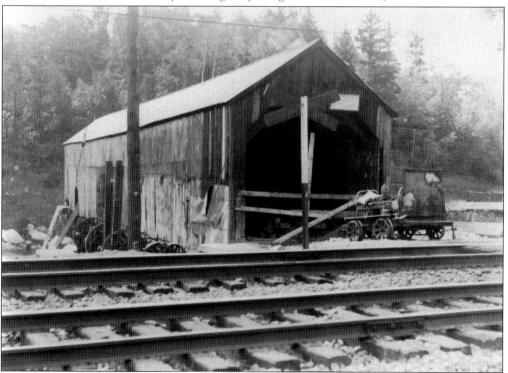

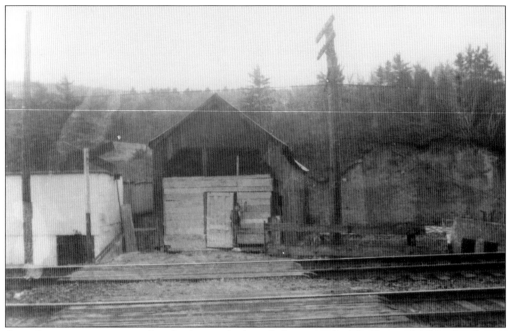

A worker exits a temporary door built into the boarded-up portal of the Erving Mill Bridge during the structure's final days. Though covered bridges are now gone from north-central Massachusetts, a number still remain in the adjacent towns of southern New Hampshire, including half a dozen along the Ashuelot River. (Photograph by William Maxant; courtesy Harvard Historical Society.)

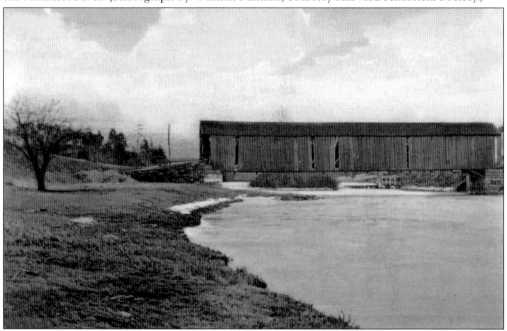

A short distance upstream from the Erving Mills was the covered bridge at West Orange, which crossed the Miller River west of the town center. After collapsing in 1907, it was replaced with a small steel bridge, which in turn was replaced with the present steel and concrete structure. (Courtesy Dick Chaisson.)

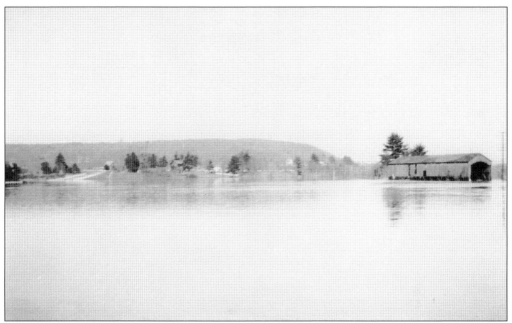

The extent of the March 1936 flood is evident in this view of the Partridgeville Bridge and the adjacent meadows along the Millers River in Athol. It was erected in 1874 along a road that had been built at the request of a town resident who wished to be able to drive his horses to town without them being frightened by the nearby railroad. (Photograph by Alice Rogers; courtesy Dick Chaisson.)

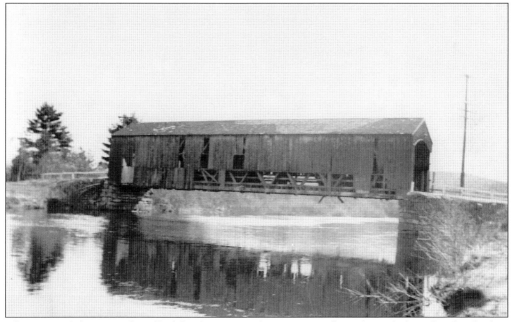

This view of the Partridgeville (also known as the Gage Road) Bridge is believed to be the last known photograph of the 100-foot-long structure before it was washed out by the hurricane of 1938. Damage to most of the lower boards is evident. The supports were made from old-growth chestnut logs cut from a nearby neighborhood. (Photograph by Alice Rogers; courtesy Dick Chaisson.)

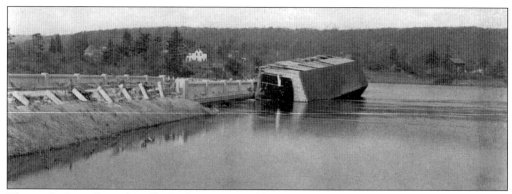

The washed-out Partridgeville Bridge is pictured here at rest against the recently opened Daniel Shays Highway (Route 202). At the time of its demise, the road the bridge served had been discontinued following the completion of the highway; however, the *Athol Daily News* reported that there had been "agitation to preserve the old bridge as the last outpost of a fading past." (Courtesy Dick Chaisson.)

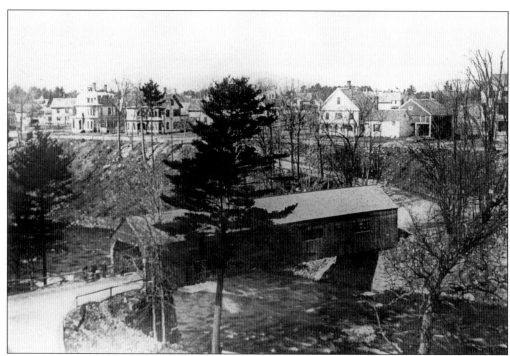

Athol's Chestnut Hill Avenue Bridge was one of many covered bridges that was also known as "The Kissing Bridge." It crossed the Millers River east of downtown Athol on the turnpike to Brattleboro, Vermont. In this view from a hillside above Starrett's Tool Company, residences in the town's Crescent Street neighborhood are visible on the north bank of the river. (Courtesy Dick Chaisson.)

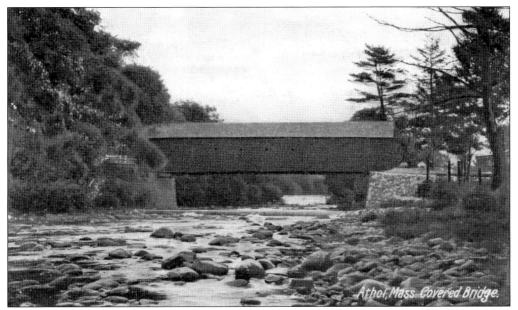

A water-level view shows the Chestnut Hill Bridge from the south bank of the Millers River. The bridge was built in 1850 and dismantled in 1921. The replacement open steel bridge was built at a cost of $15,000 and served as the only passable route in town across the river during the 1938 hurricane floods. (Courtesy Dick Chaisson.)

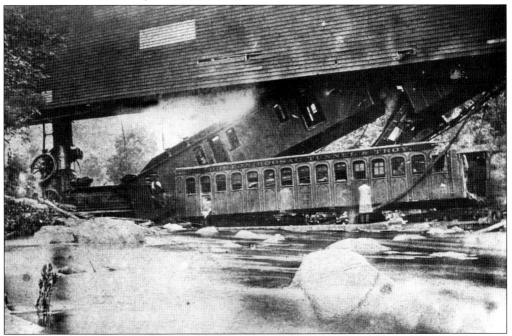

On June 16, 1870, the Long Bridge, a covered railroad bridge over the Millers River east of Athol, collapsed when a train suddenly slowed to avoid a handcar that had been carelessly parked on the tracks. Three people were killed and 20 were injured in the wreck, which received national media coverage. The bridge was destroyed by a fire in 1881, shortly before it was scheduled to be replaced. (Courtesy Dick Chaisson.)

The Old Red Railroad Bridge was another "dry" bridge that crossed the tracks of the Boston and Maine Railroad east of the center of Athol. Athol had one of the state's highest concentrations of covered bridges during the 19th century, with 15 structures listed in records. Many of these were railroad bridges that were lost by 1885. (Author's collection.)

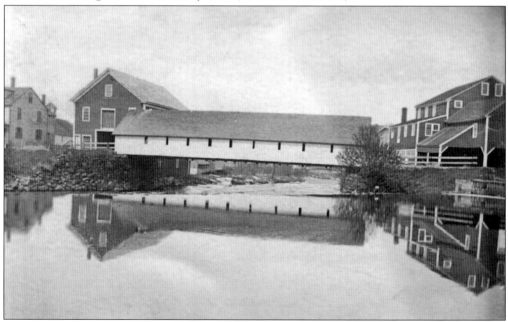

The covered bridge at South Royalston, seen here in the late 19th century, spanned the Millers River in the heart of a manufacturing center, 4 miles south of Royalston's town common. Royalston's population peaked during the height of industrial activity in the village during the mid-to-late 19th century. (Courtesy John McClure.)

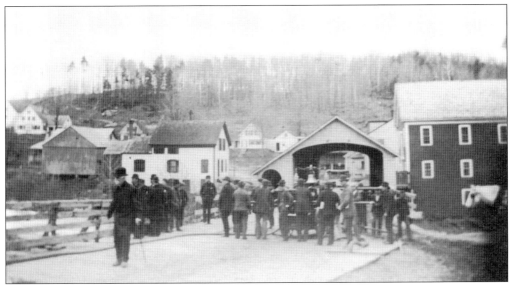

The South Royalston Bridge was located adjacent the Whitney Mill and included a pedestrian walkway. As was the case with many covered bridges in the early 20th century, there was little sentiment about its loss; in fact, one local newspaper stated that "no one would be sorry" that the old wooden structure would be replaced by an open steel bridge. (Courtesy John McClure.)

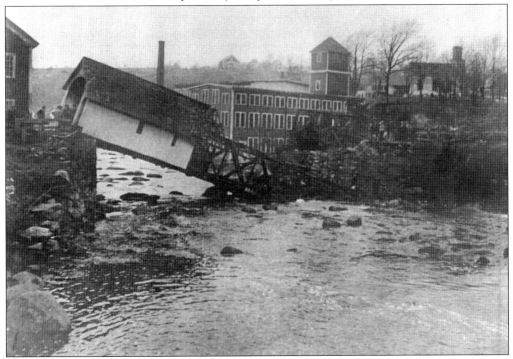

On the morning of October 25, 1904, South Royalston suffered its second devastating fire in 12 years. The inferno, which may have been ignited by a chair mill shop or from the sparks of a passing train, was fanned by a strong easterly wind and rapidly spread out of control, destroying the covered bridge and other buildings in the village, including the church, schoolhouse, and private homes. (Courtesy Dick Chaisson.)

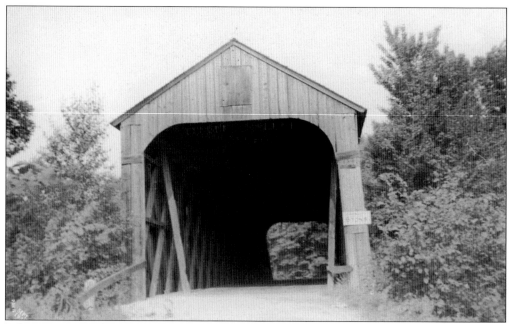

Palmer's Forest Lake Bridge crossed the Ware River on Bennett Street northeast of the town center on the Thorndike-Ware Road. Built in 1870, it received increased use by vehicles during the early 20th century after the bridge at nearby Whipple's Crossing was closed to traffic. (Courtesy National Society for the Preservation of Covered Bridges, Richard Sanders Allen Collection.)

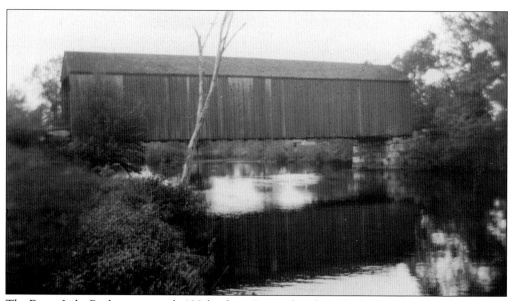

The Forest Lake Bridge was exactly 100 feet long. It was closed to vehicles by 1937, after the opening of a nearby steel bridge, and was subsequently lost following the 1938 hurricane. From 1838 to 1876, Palmer was also home to a covered railroad bridge across the Quaboag River. (Courtesy National Society for the Preservation of Covered Bridges, Richard Sanders Allen Collection.)

The easternmost of Massachusetts's remaining historic bridges is the Ware-Gilbertville Bridge, which connects the town of Ware to Hardwick's village of Gilbertville. Part of the reason for its longevity is its relatively late construction date of 1886. Note the now-abandoned railroad tracks in front of the west portal on the Ware side in this 1939 view. (Photograph by William Maxant; courtesy Harvard Historical Society.)

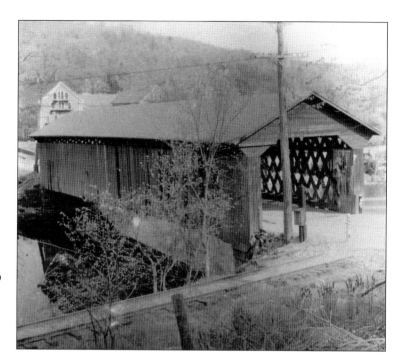

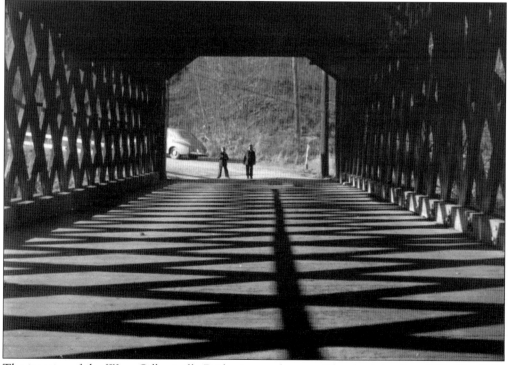

The interior of the Ware-Gilbertville Bridge is seen here on Thanksgiving Day 1947. The light and shadows of the exposed Town truss frame were caused by missing boards. This view is looking west to the Ware side of the river. (Photograph by William Maxant; courtesy of Harvard Historical Society.)

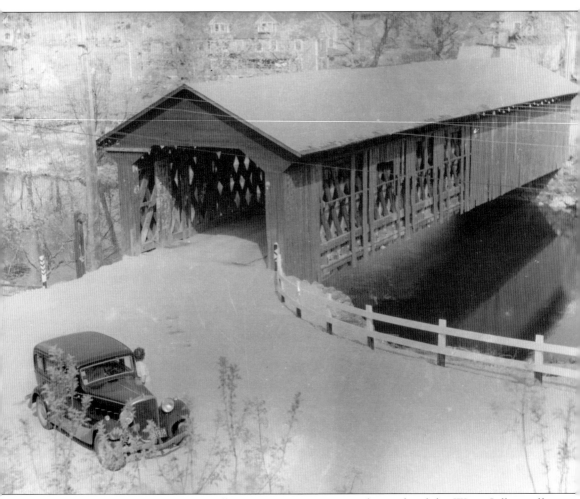

The Dodge of photographer William Maxant is positioned outside of the Ware-Gilbertville Bridge's west portal on Ware's side of the river during the spring of 1939. This bridge was the last remaining historic bridge in Massachusetts that was open to traffic. It served a lightly-traveled rural road a short distance west of the present state highway 32A for 116 years before being closed during the summer of 2002, due in part to damage from reckless driving. By the time of its closure, loads were restricted to 6 tons. The ET&L corporation from Stowe began renovations in early 2010 and the bridge is scheduled to reopen in early 2011. With the recent opening of the rehabilitated Bissell Bridge in Charlemont and the Pepperell Bridge nearing completion, Massachusetts will have three active covered highway bridges open in the near future. (Courtesy Harvard Historical Society.)

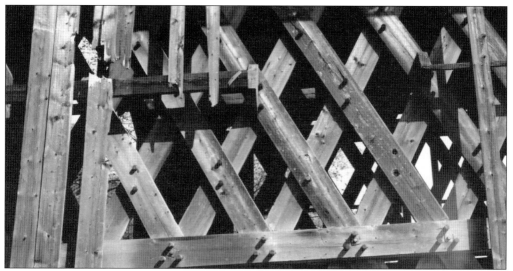

This close-up photograph shows the detail of a portion of the Town truss frame of the Ware-Gilbertville Bridge. Some fracturing of the timbers is evident in the upper left of the image, which was taken by a state bridge inspector in 1921. (Courtesy MassHighway Bridge Section archives.)

Given the extent of damage caused by the 1938 hurricane to this mill along the Ware River in Gilbertville, it was remarkable—and a testament to sound construction and good fortune—that the Ware-Gilbertville Bridge, which is a short distance downstream, survived in good order. (Courtesy MassHighway Bridge Section archives.)

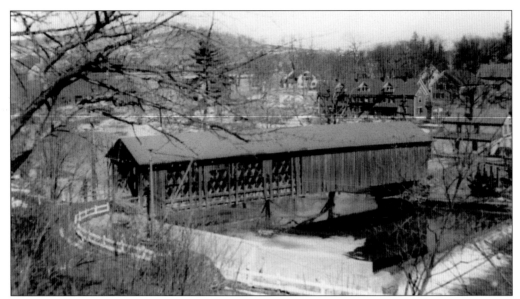

The Ware-Gilbertville Bridge, seen here in 1941, was notorious for the fact that the towns of Ware and Hardwick conducted repairs and upgrades to the 135-foot span according to their own timetables. This downstream view from the banks on the Ware side also shows residences in Gilbertville and one of the valley's rolling hills to the east. (Photograph by W. E. Robinson; courtesy MassHighway Bridge Section archives.)

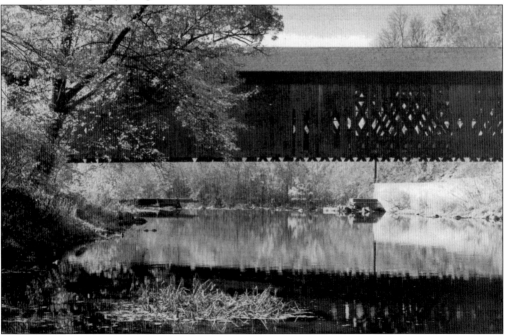

In this 1955 river-level upstream view, the frame on Ware's half on the right was uncovered and exposed. After the Ware portion was renovated, the worn Hardwick side then stood out. The bridge has the unique distinction of being a part of both Worcester and Hampshire Counties and is the only remaining covered highway bridge in either jurisdiction. (Photograph by Les Campbell; courtesy of Ware Library.)

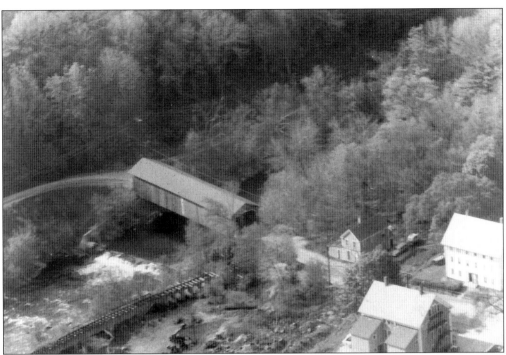

This aerial perspective of the Ware-Gilbertville Bridge was taken by William Maxant in 1971. On the right are apartment buildings on Bridge Street in Gilbertville. Note the sides that have finally been patched up; the single white board in the middle marks the town and county line. (Courtesy Harvard Historical Society.)

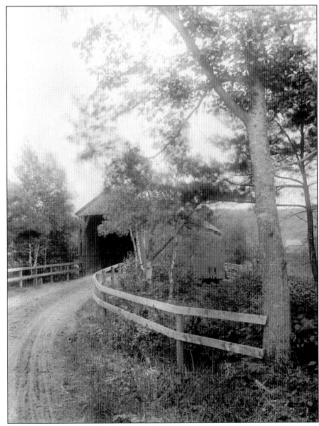

Described by Adelbert Jakeman as "undoubtedly the most isolated and least accessible of the surviving Massachusetts spans of its type," this covered bridge crossed the Ware River near a remote rural neighborhood in the central Worcester County town of Barre. It was commonly known as the Cemetery Bridge because of its proximity to the nearby Riverside Cemetery. (Courtesy Barre Historical Society.)

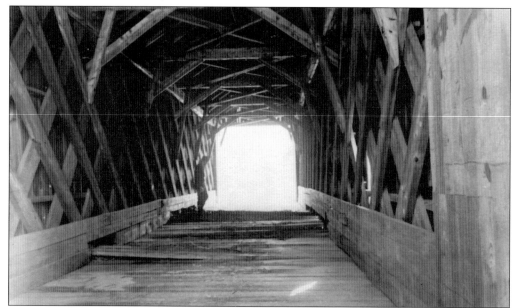

A fisherman takes shelter from the midday sun inside the Cemetery Bridge. Wear and damage to the bridge's floorboards are evident in this 1936 photograph, which was taken just two years before it was destroyed in 1938. Jakeman also noted the lack of "ancient circus posters, [as] advertising would not have paid in this lone section of the country." Visible on both sides of the image is the bridge's Town truss frame. (Photograph by Metropolitan District Commission; courtesy Barre Historical Society.)

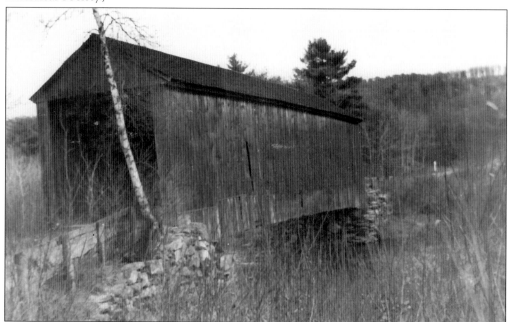

Though the Cemetery Bridge's isolation subjected it to less wear from vehicle traffic, it was another casualty of the 1938 hurricane. Floodwaters along the Ware River washed the already weakened structure off its supports, and it broke up as it washed downstream. It was the easternmost of the state's covered bridges that were lost during this time. (Courtesy Barre Historical Society.)

Today the old stone supports are the only evidence of the Cemetery Bridge's former location; no replacement structure of any sort was ever built on the site. Much of the valley here is now part of a 22,000-acre conservation area that includes the Barre Falls Dam, which was built in 1958 and has saved downstream communities millions of dollars by mitigating flood flows. (Photograph by author.)

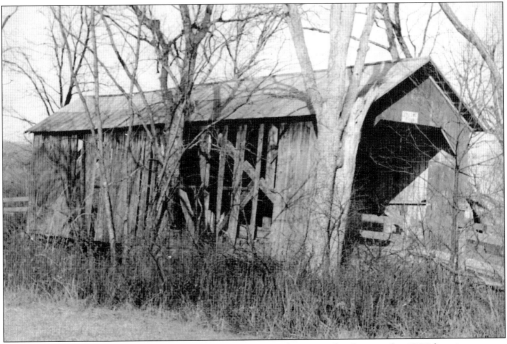

A second, even more obscure covered bridge in Barre that was also lost in the 1938 hurricane was the Red Bridge, which crossed the Ware River at Barre Plains. Extensive damage to the sides is evident in this image, which was taken in 1936. (Courtesy Barre Historical Society.)

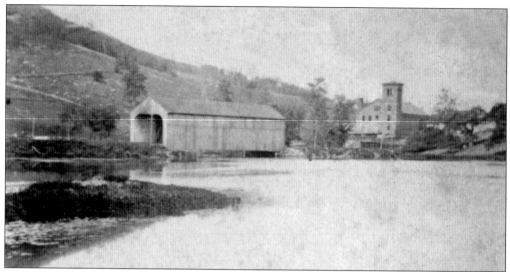

In 1838, engineering pioneer William Howe built this covered bridge across the Quaboag River at Lower Village in Warren for the Western Railroad Company. It was the first structure to feature Howe's distinctive frame, which was patented two years later. The bridge, located near the village's woolen mill, was replaced in 1873. (Courtesy Sylvia Buck.)

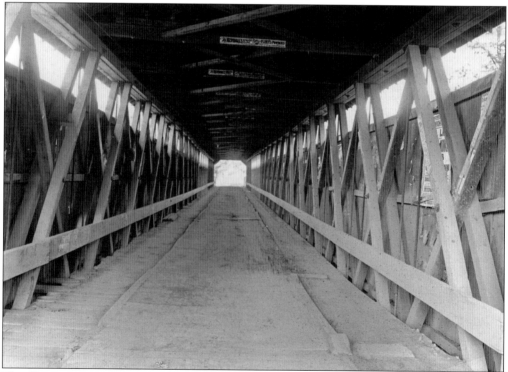

The Howe truss pioneered the use of iron rods to supplement and reinforce the wood frame of X-shaped timbers. It was an early indicator of the impending shift from the use of wood to iron in bridges. Howe's design soon became popular with both railroad and highway bridges worldwide, especially in the period just before the Civil War. (Courtesy MassHighway Bridge Section archives.)

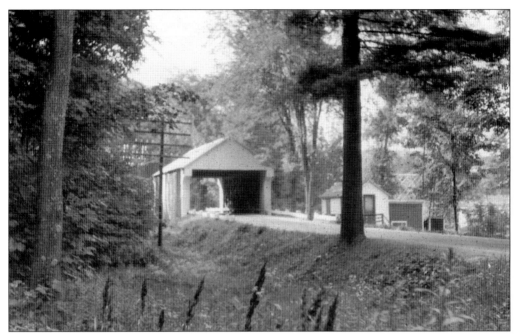

From its construction in 1870 until the early 1950s, the Taft Bridge, which is also known as the Vermont or Dummerston Bridge, spanned Sticky Brook in the town of Dummerston in southern Vermont's West River Valley. This view of the bridge was taken at its original location in 1946. (Photograph by William Maxant; courtesy Harvard Historical Society.)

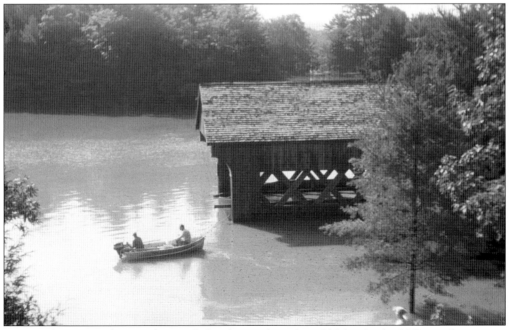

In 1951, the Taft Bridge was dismantled and moved south to Old Sturbridge Village, where it was rebuilt as a historical exhibit. Shortly after being rebuilt near an old milldam along the Quinebaug River in the village, the bridge was inundated and partially damaged by flooding caused by the hurricane of August 1955. (Courtesy Old Sturbridge Village archives.)

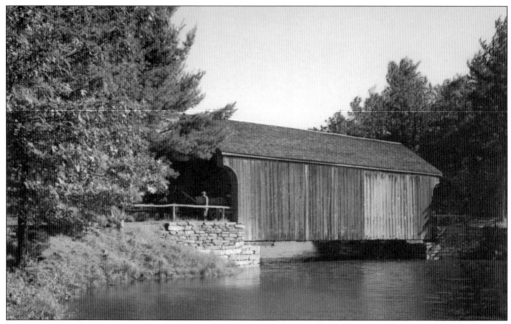

After the waters subsided, the Taft Bridge was quickly relocated downstream to a quieter, more protected corner of the river during the winter of 1955–1956. The $12,000 cost to relocate the structure within the village was nearly as much as it cost to be moved from Vermont. After supporting carriages and automobiles for its first 80 years, today the bridge is traversed by horse-drawn wagons and pedestrian visitors to Old Sturbridge Village, which is renowned for its historic exhibits that depict life in early New England. This 55-foot, single-span structure, which is short by the standards of other covered bridges, features a Town truss frame and distinctive arched portal legs. (Both courtesy Erving Public Library.)

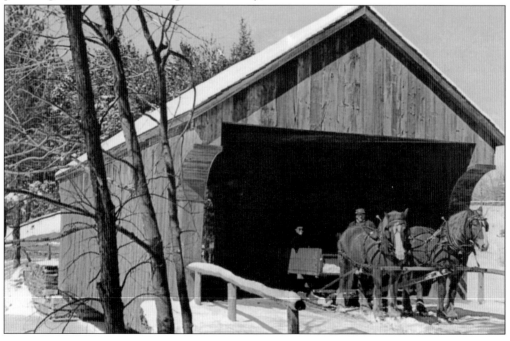

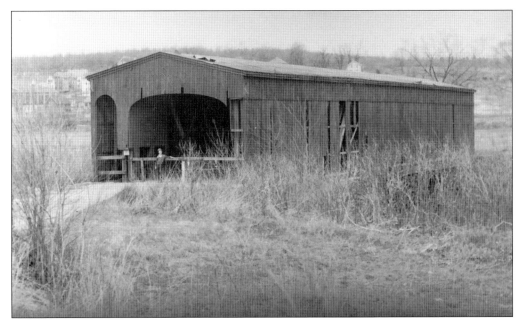

From 1888 to 1946, the village of Millville, in southern Worcester County's historic industrial Blackstone River Valley, was home to this 117-foot structure, which was variously known as the Bannigan, Bannigor Heights, or simply Red Bridge. It crossed the Blackstone River a short distance south of Canal Street. This view was taken in 1940. (Photograph by William Maxant; courtesy Harvard Historical Society.)

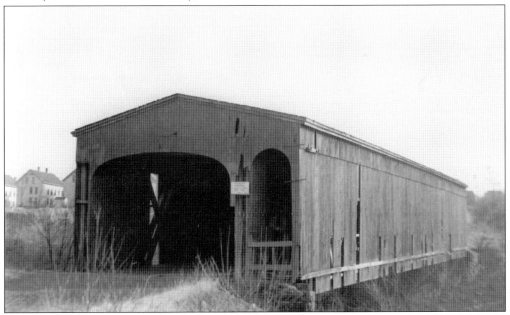

A 1941 view of the Millville Bridge, looking back toward residences in the village, reveals the oval-shaped opening that was part of a 5-foot-wide pedestrian walkway. The sign posted between the portals marked the structure as "unsafe," warning visitors to "enter at your own risk." A series of covered railroad bridges were also located in this portion of the Blackstone Valley. (Photograph by W. E. Robinson; courtesy MassHighway Bridge Section archives.)

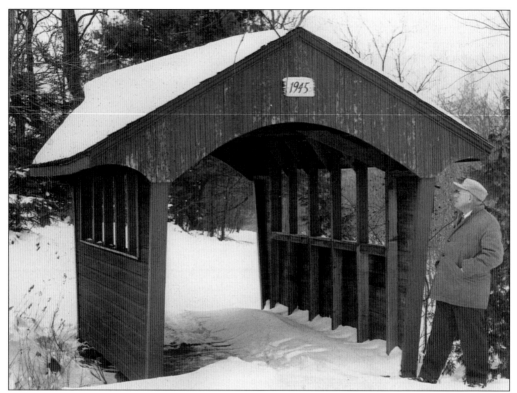

A number of the pictures featured in this book were taken by William Maxant, a successful businessman who resided in the town of Harvard and compiled a large collection of covered bridge photographs from travels throughout New England and elsewhere. He built this private structure, seen here in 1961, at his home. (Courtesy Harvard Historical Society.)

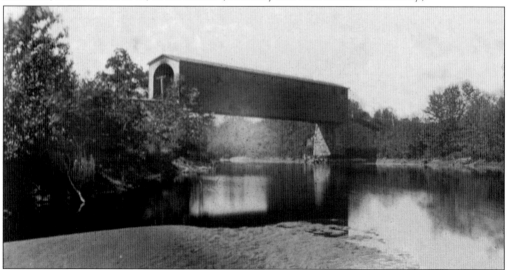

This covered railroad bridge was built and maintained by the Boston and Maine Company. It spanned the Nashua River between Harvard and Lancaster a short distance south of the busy Still River Depot, which exported large quantities of milk to markets in Boston. It was destroyed by a fire in the late 19th or early 20th century and was replaced by a steel bridge. (Courtesy Harvard Historical Society.)

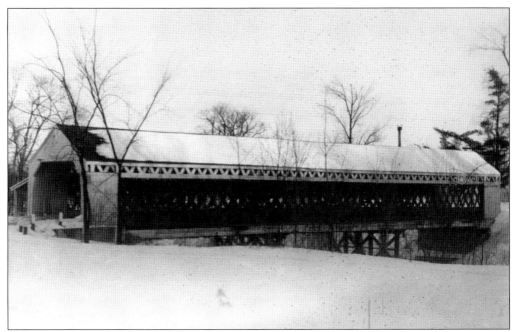

The last historic covered bridge remaining in eastern Massachusetts crossed the Nashua River at East Pepperell. Among its local names were Jewett's Bridge and the rather plaintive Pepperell No. 1. This view shows the bridge during the winter of 1939, shortly after it survived the floods of the late 1930s with minimal damage. (Photograph by William Maxant; courtesy Harvard Historical Society.)

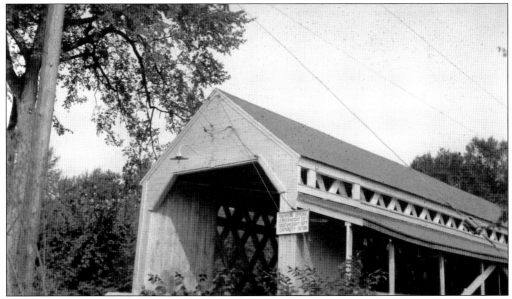

This 1937 view of the first Pepperell Bridge shows the roof of the pedestrian walkway that was added to the structure in 1920, a small light that illuminated the portal, and a sign that posted the bridge's 10-ton weight limit. It was the last historic Massachusetts bridge with a walkway, though one was added to the rebuilt Greenfield Pumping Station Bridge in 1972. (Courtesy MassHighway Bridge Section archives.)

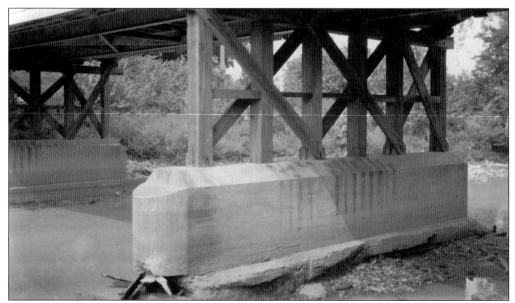

The first Pepperell Bridge was further enhanced and strengthened in 1920 by the addition of two concrete piers to help support the structure's three spans. These helped the bridge survive the floods of 1936 in good order. Reinforcing steel beams were subsequently added to handle increasing automobile traffic. (Courtesy MassHighway Bridge Section archives.)

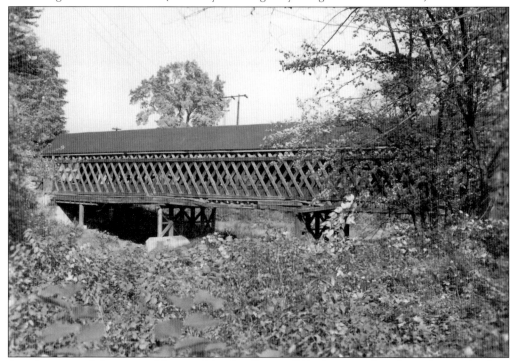

Another view of the exposed frame of the first Pepperell Bridge was taken from the riverbank in 1950. Though the visible interior, in which the bridge's Town truss frame is evident, made for an artistic photograph opportunity, the constant exposure to the elements contributed to the structure's irreparable deterioration during the 1950s. (Courtesy MassHighway Bridge Section archives.)

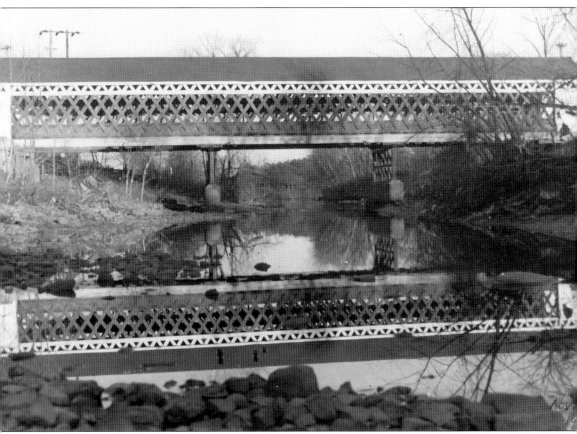

A clear reflection of the original Pepperell Bridge is seen in this c. 1939 view of the Nashua River. It was one of several Massachusetts covered bridges that were built at historic sites. During the American Revolution in 1775, a Tory spy was captured in the vicinity by a group of patriot women and subsequently taken prisoner in the neighboring town of Groton. The bridge was built in 1848 as a replacement for an open wooden structure that was lost in 1847. It was part of the Pepperell-Groton town line until 1857, when the boundary was relocated. In the years following its centennial, the 165-foot structure was the longest surviving covered bridge left in Massachusetts, as the giant spans that once crossed the wide Connecticut, Merrimack, and Deerfield Rivers were all replaced or washed out by mid-century. (Photograph by William Maxant; courtesy Harvard Historical Society.)

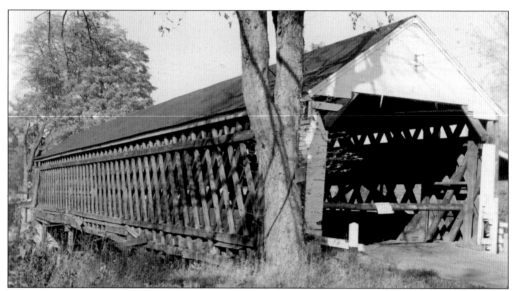

After 110 years of service, the first Pepperell Bridge was finally condemned and closed to traffic in July 1958. Damage to the frame above the portal is evident in the image below. The structure was subsequently dismantled during the early 1960s and replaced by the Chester Waterous Bridge, the last of the three modern covered bridges that were built in Massachusetts during the mid-20th century. A temporary pedestrian bridge was established across the Nashua River while the new bridge was being built. A piece of the original bridge was used for a plaque in the replacement. (Both courtesy MassHighway Bridge Section archives.)

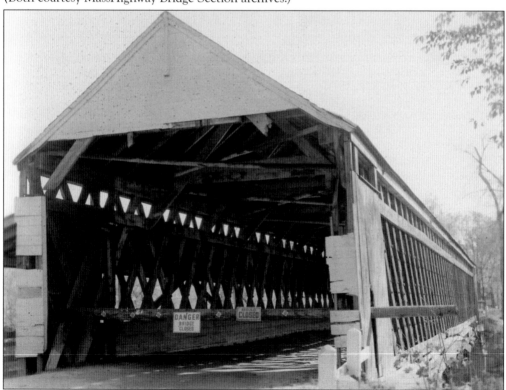

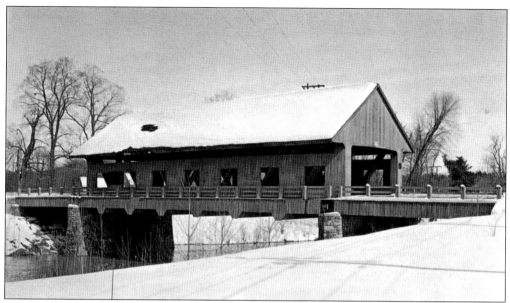

Named for the legislator who helped fund it, the Waterous Bridge was completed in 1962 at a cost of $233,000. From 2002 to 2008, it was the state's only covered bridge that was open to traffic. The Waterous Bridge was closed and dismantled in 2008. As this book went to press, a third replacement covered bridge was nearing completion and scheduled to open in 2010. (Courtesy Erving Public Library.)

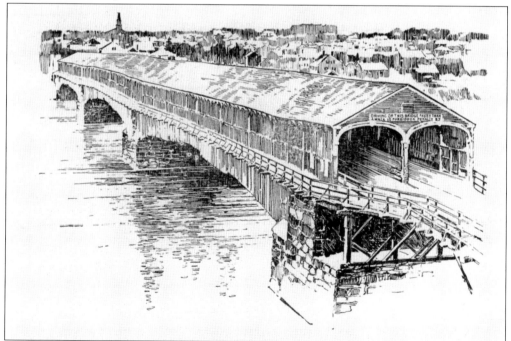

Originally built as an open wooden arch bridge in 1794, Haverhill's Palmer Bridge was designed by and named for covered bridge pioneer and area native Timothy Palmer. This hefty, double-portaled, 863-foot-long bridge was roofed in 1825; had this been done at the outset of its construction, it would have been the country's first covered bridge. It was replaced in 1873. (Author's collection.)

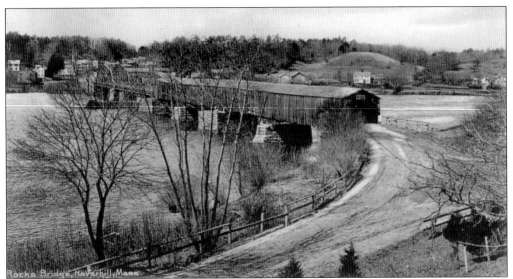

Haverhill's Rocks Village Bridge provided a crossing over the Merrimack River to West Newbury. It was built in 1828 as a replacement for a structure that had been destroyed by ice flows. This bridge was more than 800 feet long and included four covered spans. Beginning in 1896, its segments were gradually converted to steel, and the last covered section was gone by 1916. (Author's collection.)

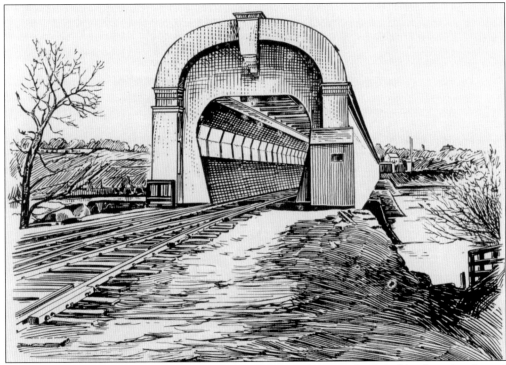

Haverhill was also home to this distinctive Boston and Maine Railroad bridge, the date of construction for which appears as both 1838 and 1868 in historical records. The roof of this five-span structure featured vents that dissipated smoke from the passing locomotives, and its portals are perhaps the most elaborate of any of the state's covered bridges. (Author's collection.)

ABOUT COVERED SPANS OF YESTERYEAR

The Covered Spans of Yesteryear project was initiated during the summer of 2003 by a small group of covered bridge enthusiasts with the goal of compiling a listing and repository of information for the more than 13,000 covered bridges that are known to have existed in the United States and Canada since the construction of the Permanent Bridge across the Schuylkill River in Philadelphia in 1804. The project has benefited significantly from the generous support of many individuals, historical societies, and covered bridge organizations that have provided access to their collections of books, notes, postcards, and photographs.

While information about existing covered bridges is readily available, details on former covered bridges are often harder to obtain. During the late 19th and early 20th centuries, covered bridges were a ubiquitous part of the landscape without the romantic appeal that is associated with them today. As iron bridges became more popular, many towns looked forward to replacing their old, dark, sagging wooden bridges with new, modern, iron, steel, or concrete structures, and hundreds of others were lost to flood or fire. As a result, many passed into history with little fanfare or acknowledgment, and details of their existence are frequently limited to photographs preserved in a local historical society, postcards, a saved newspaper clipping, or mention in a town history.

The project's Web site (www.lostbridges.com) includes a searchable database containing detailed information about each bridge with source citations, pictures (if they are available), and a listing of information sources for further research. The Web site serves as a resource for anyone interested in covered bridges, past or present. Additional information and photographs are always welcome. Visit the Web site for more details and contact information.

www.arcadiapublishing.com

MAP SEARCH

Discover books about the town where you grew up, the cities where your friends and families live, the town where your parents met, or even that retirement spot you've been dreaming about. Our Web site provides history lovers with exclusive deals, advanced notification about new titles, e-mail alerts of author events, and much more.

MADE IN THE
USA

Arcadia Publishing, the leading local history publisher in the United States, is committed to making history accessible and meaningful through publishing books that celebrate and preserve the heritage of America's people and places. Consistent with our mission to preserve history on a local level, this book was printed in South Carolina on American-made paper and manufactured entirely in the United States.

This book carries the accredited Forest Stewardship Council (FSC) label and is printed on 100 percent FSC-certified paper. Products carrying the FSC label are independently certified to assure consumers that they come from forests that are managed to meet the social, economic, and ecological needs of present and future generations.

FSC
Mixed Sources
Product group from well-managed
forests and other controlled sources

Cert no. SW-COC-001530
www.fsc.org
© 1996 Forest Stewardship Council

Find Your Place in History.